"I am in a position to help this man, yet I am in no position
myself, and I have just as much need of help as he, for I, too, mu
my living. As judge of a man's fitness for citizenship, my dec
valid; as judge of a woman's, my decision is void.

"To restore *myself* to citizenship is not within my power. I ar
less. I have no power to safeguard or regain the right I hold dea
the world, and no guarantee of preserving my means of livelihood

"What to do?

"What for myself an
hundreds of others in th
position as myself?

"For, according to Judg
penthal, of Kansas, ther
many women in my predic

"Now, citizenship is a
determined by Congress.
of 1907 (34 Stat. 1228)
vides (Sec. 3) 'that any
can woman who marries
eigner shall take the nati
of her husband,' etc.

"Therefore I must addre
prayer for relief to Congr
means of my representative

"I have done so—and v
result.

ties. And the something
constituents have to give
litical support. Women a
constituents in this sense.
sequently our prayers for
are promptly shelved."

Besides her work for su
Mrs. Boissevain is well
for her activities in varic
cial and economic move'

Mrs. Boissevain's itiner
lows:

Chicago, October 3; Sl
Wyoming, October 5; I
Montana, October 6; Ch
Wyoming, October 8;
Idaho, October 9; Portlar
egon, October 10; Seattle,
ington, October 11; S
Washington, October 13;
Montana, October 14;
Falls, Montana, Octobe
Helena, Montana, Octob
Butte, Montana, Octobe
Salt Lake City, Utah,
17; Ogden, Utah, Octob
Winnemucca, Nevada, Oct
Reno, Nevada, October
Sacramento, California,
21; San Francisco, Octo

Goes to the Equal Suffrage States
isfranchised Women

Los Angeles, October 23-24; Phoenix, Arizona, October 25;
Arizona, October 26; Prescott, Arizona, October 27; Winslow,
October 28; Trinidad, Colorado, October 30-31; Denver, Colora

STANDING TOGETHER

JMB

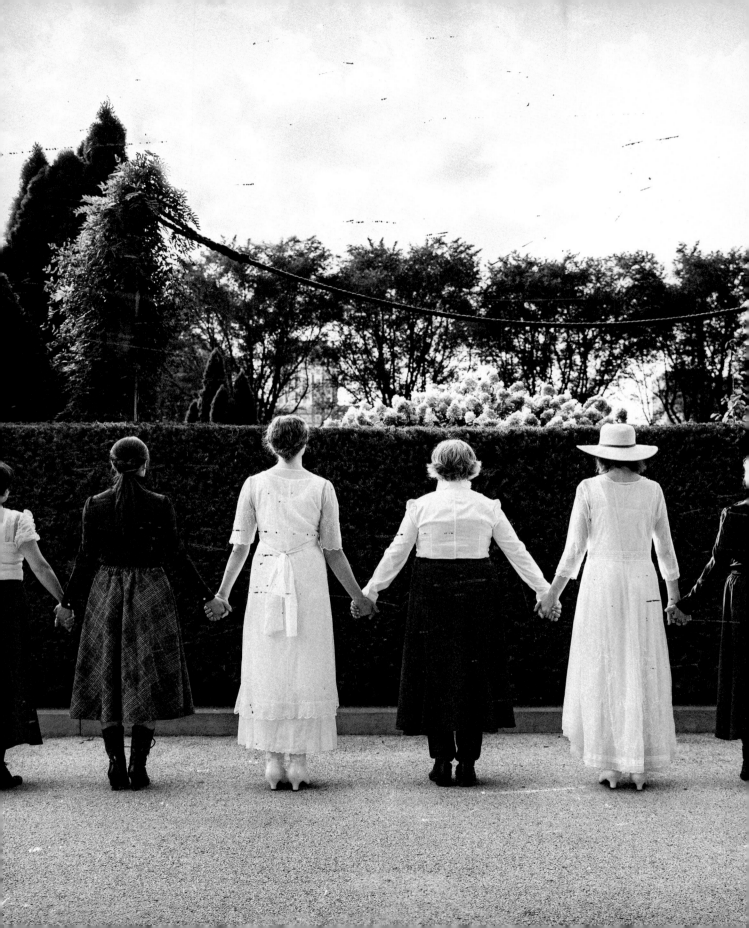

Photographs by Jeanine Michna-Bales

Introduction by Linda J. Lumsden

STANDING TOGETHER

INEZ MILHOLLAND'S FINAL CAMPAIGN
FOR WOMEN'S SUFFRAGE

ᒫ�068

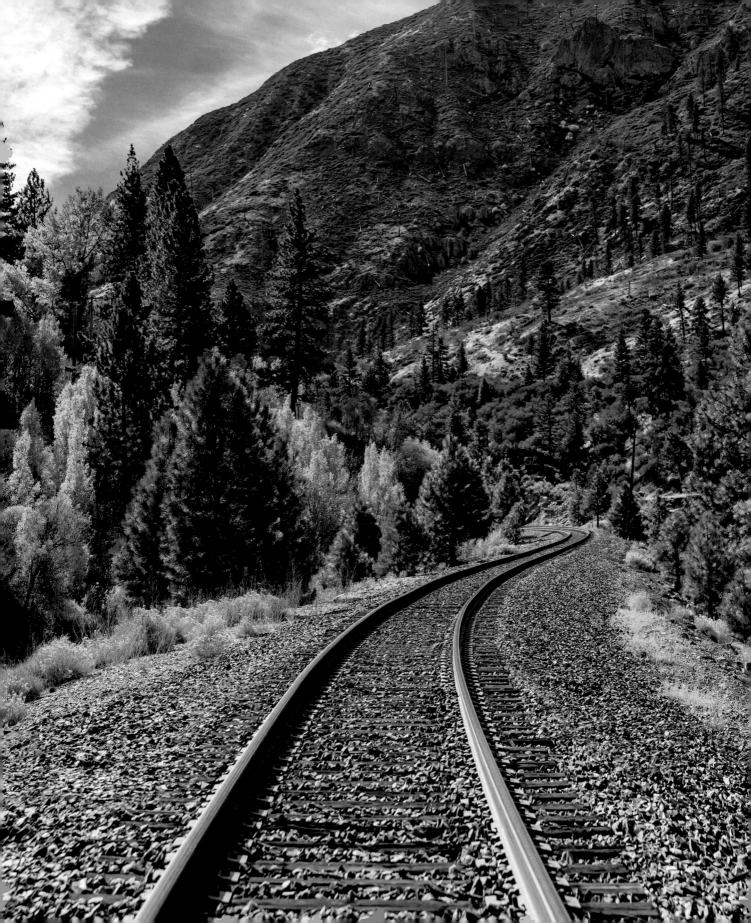

CONTENTS

Introduction 7
Linda J. Lumsden

Forward Together 15
Jeanine Michna-Bales

New York, New York *to* Chicago, Illinois 27

Chicago, Illinois *to* Cheyenne, Wyoming 45

Cheyenne, Wyoming *to* Pocatello *and* Boise, Idaho 57

Boise, Idaho *to* Medford *and* Portland, Oregon 79

Portland, Oregon *to* Seattle *and* Spokane, Washington 103

Spokane, Washington *to* Great Falls, Montana 119

Great Falls, Montana *to* Salt Lake City *and* Ogden, Utah 145

Ogden, Utah *to* Reno, Nevada 157

Reno, Nevada *to* San Francisco *and* Los Angeles, California 177

Appeal to the Women Voters of the West 199
Inez Milholland

Inez Milholland's Western Campaign Itinerary 204

Timeline of Suffrage in the United States 206

Bibliography 210

Editor's Note 213

Acknowledgments 214

FORWARD
OUT OF DARKNESS
LEAVE BEHIND
THE NIGHT
FORWARD
OUT OF ERROR
FORWARD
INTO LIGHT

Introduction

Linda J. Lumsden

The last place Inez Milholland wanted to go in October 1916 was the Wild West, even if the four million women who lived in the twelve states where women voted represented a full third of the ballots needed to elect the next president. But suffrage crusader Alice Paul was unused to taking "no" for an answer.

The suffrage campaign had been gathering momentum all year. Paul's conservative rival, Carrie Chapman Catt—newly reappointed leader of the venerable National American Woman Suffrage Association (NAWSA), a product of the 1890 merger between the National Woman Suffrage Association and the American Woman Suffrage Association—switched NAWSA's focus from education to mobilizing its two million members into a political action group. She largely dropped NAWSA's cumbersome state-by-state route to follow Paul's call for a constitutional amendment that would grant all American women the vote. In June, Catt addressed both the Democratic and Republican national conventions in Chicago. Even though suffragists packed the convention halls, neither party added the suffrage amendment to their planks. Catt called an emergency NAWSA convention in September to adopt her "Winning Plan"[1] to concentrate on a federal amendment, bolstered by a crackerjack lobbying team that buttonholed congressmen in the nation's capital. The incumbent president, Woodrow Wilson, even popped by their headquarters to express support, although he failed to officially speak out for the amendment. U.S. Supreme Court Justice Charles Evans Hughes, Wilson's Republican opponent, however, did endorse the suffrage amendment.

Paul also traveled to Chicago that June, sandwiching the inaugural convention of her potentially revolutionary new Woman's Party of Western Voters between the Republican and Progressive party gatherings. She had recruited 1,500 delegates for the first female political party in typically spectacular manner, dispatching a "Suffrage Special" train from Washington, D.C.'s Union Station, filled with the movement's best speakers, on April 9. They were led by Harriot Stanton Blatch, a veteran of the militant British "suffragette" campaign[2] and daughter of Elizabeth Cady Stanton, who in 1848 organized the seminal Seneca Falls Convention for women's rights with Susan B. Anthony, where women first officially demanded the ballot. The "Suffrage Special" blasted through fifty western cities in five weeks.[3]

Paul believed the Chicago convention marked a milestone in women's political history, heralding women's imminent arrival as a political power. The women who packed Chicago's ornate Blackstone Theater cheered, claiming they held the key to the White House. Millionaire suffragist Alva Belmont pledged a half-million dollars to the campaign for suffrage during the fall presidential campaign. The gathering so unsettled the anti-suffrage *New York Times* that it accused the Woman's Party of wielding sex for political blackmail.

Inez Milholland delivered the keynote at the "Suffrage First!" luncheon on the convention's third and final day. The phrase referenced the party's demand that votes for women not take second place to the looming world war that had ignited Europe. As Milholland rose to speak, she threw her trademark picture hat onto the dais and declared she was tossing her hat in the ring. "Suffrage for women is a gift of no one to confer," she said. "It's a right!"[4] The crowd went wild. A half-century later, suffragist Mabel Vernon still recalled Milholland's magnetism at that moment. "Not just beautiful," she recalled, "but brilliant."[5]

Paul also appreciated the statuesque Vassar College graduate's incandescent appeal. Three years earlier, she had recruited the twenty-six-year-old Milholland to ride a white horse as herald of the national suffrage parade in Washington, D.C. on the eve of Wilson's inauguration on March 3, 1913.

Milholland had blossomed as the poster girl for suffrage as soon as she stepped into her first suffrage parade in New York on May 7, 1911, bearing a banner whose message became forever associated with her: "Forward out of darkness/Leave behind the night/Forward out of error/Forward into light!"

Like Milholland, Paul had participated in England's colorful suffragette movement, not only marching in the spectacular parades but also being arrested seven times for civil disobedience. Imprisoned three times, Paul joined the jailed suffragettes' hunger strike for political prisoner status. It took four jailers to hold Paul while a doctor force-fed her through a tube. Paul returned to the United States determined to enliven the dormant American movement by importing the British suffragettes' theatrical parades and other protests—medieval-like spectacles that wed feminism with femininity. After volunteering to chair NAWSA's moribund

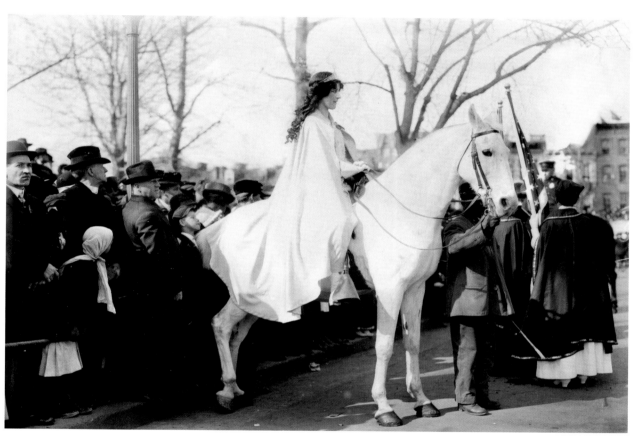

Inez Milholland at the National American Woman Suffrage Association parade in Washington, D.C., March 3, 1913

MY HOPES OF SUFFRAGE.

The source of a race is in its mothers. No race rises higher than its source. I hope and expect Suffrage to bring into existence a nobler type of motherhood, a finer type of woman generally. I expect the grave broad questions with which woman is to be brought in contact to make of her a broader, braver larger-hearted human being. In the days to come woman engaged in healthy activities of large scope will have no time for pettiness and personalities. Their vision is to be enlarged, their sympathies made more quick, their purposes solidified. Contact with the world and world's affairs is going to give them something of the rough sagacity and humor that men have learned in dealing with life. They are going to be more generous, more companionable, more whole souled and wholesome. They are to be more truly mates for men when they can share with them their activities and interests along than those merely sentimental. They are to participate joyously with men in the workaday world, in the business world, in the intellectual world, in the world of sports and healthy activities and in the world of science and high endeavor, in the world of achievement and purpose. They are to be more allround good sports, temperate thinkers, self-controlled

All of this does not mean that woman is to loose any of the qualities which are known as womanly qualities and which the race cherishes and wishes to preserve. Woman's tenderness is not to vanish it is to be deepened and increased. Woman's affectionate sympathies are not to be quelled. They are to be enlarged, more widely applied. Woman's swift intuition is not to be negatived It is to be given wider scope. Mankind ought to rejoice in the emancipation of woman which is to affect

Draft of "My Hopes of Suffrage," a speech by Inez Milholland, ca. 1910

Congressional Committee that ostensibly lobbied for a constitutional amendment, she and Vice Chair Lucy Burns immediately organized an unprecedented national suffrage parade and pageant on Pennsylvania Avenue, the symbolically rich epicenter of American politics. Paul refused the D.C. police chief's demand that they march on a remote side street.

A smitten press lauded the sight of the glamorous Milholland at the head of the kaleidoscopic procession of twenty-six floats, ten bands, and more than five thousand marchers in color-coordinated sections. Beautiful embroidered banners of satin and velvet employed traditional female arts to proclaim their radical demand to vote. The suffragists scored an unexpected publicity coup after a drunken mob swarmed the avenue. Men spat upon marchers, tripped them, pelted them with cigar stubs, pulled them off floats, tore at their skirts, and screamed obscenities at them. The U.S. Cavalry was called from nearby Fort Myers to quell the riot, which sent more than one hundred people to the hospital. Milholland emerged a hero after she galloped her horse into the mob and led the besieged women to their destination at the U.S. Treasury Building portico, where barefoot suffragists in classical Greek gowns staged Hazel MacKaye's lavish pageant, "The Allegory," tracing the history of women through the ages.

Newspapers across the nation contrasted the suffragists' dignity with the disgraceful mob. Senate hearings extended the debacle into a nationwide conversation on women's place in American society. The press's defense of the women's right to peaceably protest proved an important step toward acknowledging that women possessed other civil rights—such as the right to vote. Paul met with President Wilson the following March, and the Senate reactivated its moribund Woman Suffrage Committee, which, for the first time in more than twenty years, issued a favorable report. The publicity reinforced Paul's political strategy to always "keep the people watching the suffragists."[6]

Paul soon launched the Congressional Union for Woman Suffrage (CU) to augment the NAWSA Congressional Committee's work for a federal amendment. She once again borrowed from the Brits during the 1914 mid-term congressional elections by campaigning against the party in power—the Democrats—solely on the grounds that it had not endorsed the federal amendment. Although the tactic was better designed for parliamentary politics, the CU's efforts helped defeat twenty-three of forty-three Democratic congressional candidates. The strategy confused some voters, and angered Democratic candidates who supported votes for women. The following fall, the CU's Sara Bard Field drove an automobile from San Francisco, gathering a half-million signatures on a mammoth petition she delivered to Congress in Paul's typically spectacular style. The CU's increasing flamboyance—one member unfurled a suffrage banner during a session of Congress—angered NAWSA, which cut all ties to the organization and replaced Paul and Burns on its Congressional Committee.

Inez Milholland's letter to Alice Paul regarding the Western campaign for suffrage, 1916

Milholland became more involved with the CU while simultaneously struggling to launch a career in the male bastion of the law after having graduated from New York University's School of Law in 1912. Milholland advocated votes for women all over the city—on stages, atop soapboxes, in magazine articles, at Grant's Tomb, and before the New York State Senate, which she addressed in February 1915 as part of a rally celebrating the legislature's decision to hold a suffrage referendum in November. She saddled up again to lead some fifty thousand suffragists dressed mostly in white in New York's 1915 suffrage parade along Fifth Avenue, cheered by a half million onlookers. She also raced around the city like a progressive white knight in campaigns supporting striking retail clerks, better treatment of prostitutes, the abolition of capital punishment, and the elimination of censorship. But her pace was draining. Claiming exhaustion, she begged off appearing in a vaudeville routine touting votes for women. She also was trying to conceive a child with her husband, Eugen Jan Boissevain—and was secretly devastated that she seemed unable to get pregnant. Unsuccessful stints as a would-be war correspondent on the Italian front in the summer of 1915 and as a member of Henry Ford's ill-fated Peace Ship expedition to Europe that December—an attempt to mediate an end to World War I—had further shattered her confidence.

As the 1916 election approached, Paul turned again to Milholland and the British technique of campaigning against the party in power to protest Wilson's refusal to back a suffrage amendment. Suffrage had emerged as a mass movement, thanks to Catt's reorganization of NAWSA and Paul's flair for publicity via the CU and Woman's Party, both of which would merge into the National Woman's Party in 1917. The influential General Federation of Women's Clubs endorsed suffrage, and NAWSA was the nation's largest volunteer organization. Montana elected Woman's Party member Jeannette Rankin as the first female member of the House of Representatives. Meanwhile the war threatened to subsume news about the burgeoning suffrage movement. Paul was determined to keep votes for women on the public and political agenda.

Paul asked Milholland to serve as a "special flying envoy"[7] for the new Woman's Party campaign across the West during that fall's presidential campaign. The Woman's Party campaign was groundbreaking because it asked women voters to bond because of their gender rather than other markers such as marriage or class. Milholland initially begged off: her law practice was finally gaining traction, and an appeals court was due to rule on a new trial for a client on death row. She could muster little enthusiasm for an anti-Democrat campaign that in effect promoted the GOP's Charles Evans Hughes, whom she called a "stuffed shirt."[8] She felt exhausted, her head ached, and her heart sometimes beat oddly. Paul sweetened the deal by offering Milholland the keynote speech at the campaign's climactic rally in Chicago on the eve of the election. Milholland's wealthy father, John Milholland, also pushed her to make the trek. Having envisioned his luminous daughter someday winning a seat in Congress, he knew the whistle-stop tour across the West would place Inez in the national media spotlight. After Alva Belmont reneged on her offer to finance the campaign, John Milholland stepped in to foot the $5,000 bill for the Western campaign. Inez's younger sister Vida agreed to accompany her. A lyric soprano, she planned to sing suffrage songs at each stop. Feeling less assured and robust than she appeared to adoring fans, Inez reluctantly left New York on a train headed west on October 4, 1916.

Notes

1. *Woman's Journal and Suffrage News* 53, no. 38 (September 16, 1916).
2. British newspapers ridiculed suffragists who took to public protests as "suffragettes," but the militants reappropriated the intended pejorative as a compliment and proudly applied the label to themselves. The term never really caught on in the United States, and even Alice Paul named her newspaper *The Suffragist*.
3. *The Suffragist* 4, no. 13 (April 1, 1916) p. 7.
4. *The Suffragist* 4, no. 25 (June 17, 1916) pp. 4, 7.
5. Mabel Vernon, interview, Suffragists Oral History Collection, University of California, Berkeley. Microfiche.
6. Inez Haynes Gillmore, *The Story of the Woman's Party* (New York: Harcourt, Brace, 1921), p. 31.
7. *The Suffragist* 4, no. 42 (October 14, 1916) p. 7.
8. Inez Milholland to Alice Paul, 1916. National Woman's Party Records, Group I, Manuscript Division, Library of Congress.

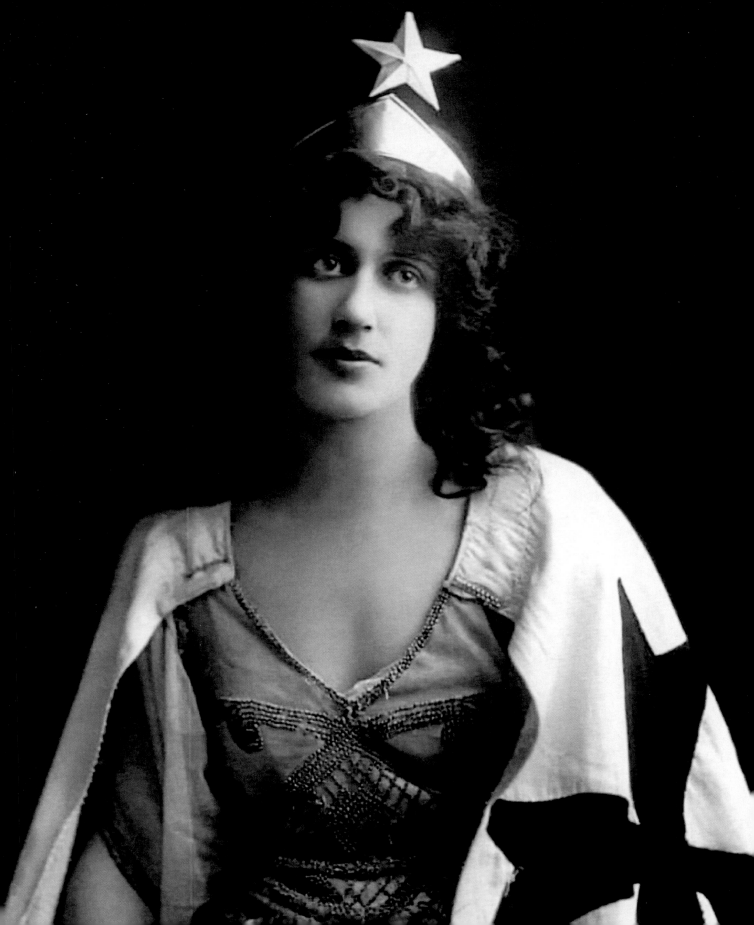

Forward Together

Jeanine Michna-Bales

In 2016, while visiting family in Indianapolis, I found myself digging through file folders of the Women's Franchise League of Indiana. I'm not quite sure what compelled me to do this, but I had been thinking about women's rights—and the lack thereof—for a long time. I had learned little about women's rights, particularly the American women's suffrage movement, in school. Why was the history of a century-long political struggle not better known? Why didn't I have a more complete understanding of what women had to fight for in order to secure the rights that I and other American women have today? I wondered how we could bring these heroic women back into our collective history.

I began delving into the annals of women's rights in the United States, including women's enfranchisement. In the late 1700s, Massachusetts, New Hampshire, New York, and New Jersey had no gender restrictions on voting, and New Jersey had no racial restrictions either. However, once states started to write their own election laws, the passage of the first anti-suffrage laws reserved the right to vote for white men, starting with New York in 1777. The subsequent state-by-state revocation of voting rights based on gender and race set a chilling precedent that feels even more ominous given the current political climate in our country.

The quest for women's suffrage in the U.S. was a multigenerational movement spanning more than a century. In a country that claims to be a democratic republic, more than half of its population was disenfranchised at the turn of the twentieth century and was denied the same rights as men. Prevailing societal views that

persisted well into the twentieth century held that women's biological inferiority to men rendered them incapable of effectively participating in politics, commerce, and public service. As I was going through the Woman's Franchise League files from 1915–20, I became fascinated with the women who worked tirelessly—meeting, strategizing, and writing letters to every influential man in the state of Indiana, imploring them to call a special session of the Indiana Congress in order to put forth a referendum granting women the right to vote in 1917. Each letter included a pledge card requesting that the man sign and return it in support of women's enfranchisement in Indiana. Every response was saved; a few expressed support for the referendum. But I was dumbfounded as I read the many responses—handwritten in elegant script—filled with derogatory remarks and stereotypes, proudly signed at the bottom, foreshadowing the measure's defeat.

I was searching for a way to visually draw people into the women's suffrage story when I stumbled across a banner (see p. 6) that was carried by a now little-known figure who was at the forefront of the movement in the early twentieth century, Inez Milholland Boissevain (1886–1916). The first and last lines of the banner read, "Forward out of darkness . . . Forward into light!"[1] I believe that the universe works in mysterious ways. My previous book was entitled *Through Darkness to Light: Photographs Along the Underground Railroad* (2017). When I saw the words on that banner, I knew that Inez would be the woman to help me personalize and visualize a movement of thousands of women.

As I researched Inez's life, I became enamored. Driven by her belief that women were equal to men, this epitome of the "New Woman"[2] challenged traditional gender norms in the early 1900s by becoming a lawyer, activist, war correspondent, suffragist, and orator. She wrote speeches, letters, plays, and articles arguing that women were worthy of the right to vote. As I read her words, often in her own handwriting, I could almost hear her voice in my head enumerating the ways in which women were competent, capable, intelligent, and active contributors to modern society—thoughtfully and methodically countering each argument that attempted to deny a woman's status as equal to men in the world. Sometimes I felt that, if the dates were removed, we wouldn't know that her words had been written more than a century earlier. When she saw an injustice, she threw herself full-force into fixing it. From labor laws and prison reform to war and women's rights, she fought tirelessly to dispel the stereotypes about women she kept butting up against, and each rejection only fueled her determination more. She was turned away by three Ivy League law schools and denied access to the front lines as a war correspondent because of her gender. She graduated with a law degree from New York University in 1912 and later practiced law despite the fact that it was a male-dominated profession.

Aboard a ship on the way to England in 1913, Inez met what could be described as her soul mate, a Dutch coffee importer named Eugen Jan Boissevain. After a

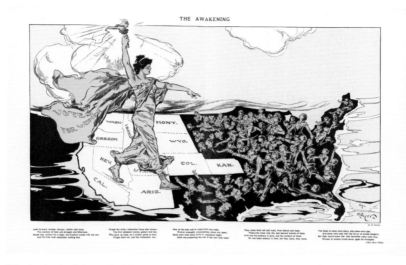

THE AWAKENING

"The Awakening" shows the Western states where women had the vote in white, with a figure bringing the light to the states in the East where women were clamoring for suffrage. *Puck Magazine*, February 20, 1915. Illustration by Hy Mayer, text by Alice Duer Miller

whirlwind courtship during which she proposed, they enjoyed a marriage that, according to their letters, was based on equality and a mutual admiration for one another. One unfortunate consequence of their union, though, was the loss of her American citizenship. Although she was born in the United States, Inez was compelled by law to become a citizen of her husband's country, thereby also losing any possibility of voting. (New York State did not grant women the right to vote until 1917). A man who married a foreign woman at the time, however, did not lose his American citizenship. Eugen offered to become an American citizen in order for her to gain her legal status back, but she refused, saying that somehow they would get the law changed.

Inez helped fellow suffragists Alice Paul and Lucy Burns form the National Woman's Party (NWP), whose goal was a constitutional amendment for women's suffrage. Frustrated by the lack of progress in a state-by-state method of securing the vote for women as well as President Woodrow Wilson's inaction on the matter, the party sought to put their fate directly into women's hands. The NWP mounted a radical campaign to send a dozen suffragists from the East out to twelve Western states and territories—Alaska, Arizona, California, Colorado, Idaho, Kansas, Montana, Nevada, Oregon, Utah, Washington, and Wyoming—where women had the right to vote. Their request was simple but substantial: put aside all other political agendas during the 1916 presidential election, then cast a protest vote against Wilson—the Democratic incumbent who was running for a second term against the Republican candidate, Charles Evans Hughes—and other Democrats also running for office. Knowing that their efforts would not likely change the outcome of the election, they nonetheless wanted to ensure that President Wilson

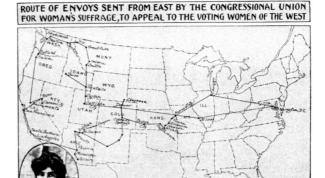

VOTES FOR WOMEN A SUCCESS

SUFFRAGE GRANTED:
1869 Wyoming
1893 Colorado
1896 Utah
1896 Idaho
1910 Washington

The Map Proves It

SUFFRAGE GRANTED:
1911 California
1912 Oregon
1912 Arizona
1912 Kansas
1913 Illinois

1913 Alaska

Would any of these States have adopted EQUAL SUFFRAGE if it had been a failure just across the Border?

Imitation Is The Sincerest Flattery!

ROUTE OF ENVOYS SENT FROM EAST BY THE CONGRESSIONAL UNION FOR WOMAN'S SUFFRAGE, TO APPEAL TO THE VOTING WOMEN OF THE WEST

MISS ALICE PAUL, NATIONAL CHAIRMAN, CONGRESSIONAL UNION FOR WOMAN SUFFRAGE

A National American Woman Suffrage Association flyer showing Nevada as the last "dark spot" of unenfranchised women in the West on the suffrage map, 1914

The cross-country route of "The Suffrage Special," created by Alice Paul and Lucy Burns in 1916 for the Congressional Union for Woman Suffrage, which Inez Milholland followed roughly for the National Woman Party's Western Campaign, later in 1916

would not win on account of women's votes in the suffrage states. The goal was to force him to acknowledge the bloc of Western women who would vote to stand together with their unenfranchised sisters in the East, and in turn live up to his democratic ideals by passing a national suffrage amendment in his next term.

Inez was appointed as a "special flying envoy" to make a 12,000-mile swing through the West in October 1916, immediately preceding the election. Before she agreed to embark on the tour, she struggled with the tactic of campaigning against President Wilson. She knew that if she didn't believe in what she was speaking about, her lack of passion for the subject would be obvious. She convinced herself that she wasn't *for* Hughes, or the Republicans in general, as much as she was *against* the political party who had continued to ignore women's demand for the right to vote.

Inez and her sister Vida, traveling via train, left New York City on October 4, 1916, stopping first in Chicago to meet with Alice Paul at the NWP headquarters. In a letter to her husband, Inez wrote that she had "a horrible journey to Chicago"[3] and was "sickest every bit of the way."[4] She attributed her pain "in head, shoulders, and back . . . coupled with dizzy headaches"[5] to the train, writing that she would get used to it after a bit. She saw reporters in the afternoon, and then saw the first of many doctors during the trip, who said that her "tonsils were in awful shape."[6] The night before the campaign began, the Milholland sisters had drinks and dinner with their father, John. He would later express concern for Inez's health in his diary pages.

Departing Chicago on October 6, Inez and Vida embarked on a grueling campaign traversing eight states in twenty-one days, only a portion of the twelve states they were meant to cover. Inez delivered some fifty speeches while battling chronic illness and lack of sleep. Her three-week itinerary, brutal even by today's travel standards,

consisted of street meetings, luncheons, railroad station rallies, press interviews, teas, auto parades, dinner receptions, speeches in the West's grandest theaters, and even impromptu talks on the train while on the way to her next destination.

They arrived after midnight on Saturday, October 7, at their first stop, Cheyenne, Wyoming, and were met by a local NWP member, who walked them over to the Plains Hotel. Inez said she "felt like the devil in the morning, but got better during the course of the day."[7] She spoke in the afternoon to a crowd at the hotel, and Vida, who was an accomplished lyric soprano, sang.

Vida had arranged for them to travel in a private car between Cheyenne and Pocatello, Idaho—the next leg of the journey. The press blasted them for this, citing the expense and demanding to know who was funding the campaign. After that, the Milholland sisters would often board a crowded train with no open sleeping berths, and a sleepless ride would stretch through the night. But the meetings, often many per day, continued. Inez was "doctoring hard"[8] to cure her sore throat, aches, pains, and fevers by taking prescribed arsenic, strychnine, and iron pills to get through each day.

In Pocatello, the meeting at the Yellowstone Hotel was so crowded that three hundred men gave up their spots for women. After the meeting, Inez and Vida boarded a mail train and rode, without food, to Boise, where they headed to the Pinney Theater. Inez spoke with Sara Bard Field—a poet and suffragist who had driven an automobile cross-country the year before, collecting signatures on a suffrage petition—to an audience "filled to [the] limit" with "scores standing."[9] Inez remained on stage until 10:30 p.m. answering questions. Inez, Vida, and Sara Bard Field celebrated the successful meeting before the sisters boarded a 2:00 a.m. train to Portland, Oregon. "It was a wonderful meeting—about 1,500—and [I] landed it. I am so happy," Inez wrote to Eugen.[10]

With whistlestop speeches at various train stations along the way, the Milhollands continued through Nampa, Idaho, and into Oregon, passing through Pendleton, The Dalles, Hood River, and on to Medford—where Inez spoke in the afternoon at a crowded meeting at the Medford Public Library—and finally into Portland that evening.

As she traversed the country, Inez wrote detailed letters to Eugen. "Well, I am seeing the West, and it is very wonderful. It is absurd and inadequate for me to see beautiful things without you."[11] The letters, telegrams, and flowers that he sent her along the campaign trail were like fuel propelling her through the journey. "I got your telegram when I got into the hotel, and it spurred me on for the meeting,"[12] she wrote in one letter to Eugen, penned on the train at 2:00 a.m. She counted down the days until she would see him again at the end of the campaign, in Illinois: "Each meeting, I say 'one less till Chicago.'"[13]

As the train made its way down the Columbia River into Portland, the "sunset splashed the mountains and river with crimson."[14] Upon their arrival at Union

Station, Inez and Vida were greeted by reporters and photographers who followed them to the Multnomah Hotel, where a banquet for five hundred was given in honor of Inez. (Another two hundred people had to be turned away.) Inez shook hands with guests after dinner and huddled one-on-one with journalists until after midnight, when the sisters caught the next train to Seattle, arriving at King Street Station, swathed in fog, just after the crack of dawn. They were escorted to a luncheon, attended by one hundred prominent citizens, at the Sunset Club, then Inez spoke at the Land Show Expo, headed back to the Sunset Club for a banquet dinner, and ended the day at Moore Theatre for a mass meeting of nearly three thousand people. She lingered on the stage of the packed theater, answering questions until she was dragged away by Vida. As the journey continued, her confidence as an orator was growing. In a letter handwritten on Sunset Club letterhead, she wrote to Eugen: "Had a marvelous meeting last night. Quite the best yet. Even I was satisfied. I'm learning and getting to be a real speaker."[15]

Inez and Vida went to Spokane, where the press coverage of an afternoon reception for more than three hundred women at the home of Mrs. Austin Corbin II was positive and mentioned the decorations of "huge brown baskets . . . banked with barberries, Oregon grape and yellow maple leaves, and . . . red and blue berries."[16] The more seasoned suffragists described their many years of battle as "A Good Fight," and asserted that "this year will go down in political history under the title of 'First Battles of the Women's War.'"[17] Later that night, according to the *Spokane Daily Chronicle*, "the standing-room only sign was dusted off and hung up 30 minutes before the meeting opened"[18] at the Strand Theater. After delivering a speech to a crowd of 1,800 people, Inez asked the men in attendance if she was on the right track. A chorus of baritone voices responded with, "Yes, you're alright!"[19]

From there, Inez and Vida traveled to Cut Bank and Shelby, both in Montana, for a train platform speech and street rally, then continued on to Great Falls, Montana, where they were greeted by a large crowd and the Black Eagle Brass Band. The automobile that escorted them to the Palace Theater, where Inez spoke that night to a crowd of 1,100 people, was part of an auto parade, which included a car filled with Blackfeet Indians "in full war paint."[20] They ate dinner and went dancing, but the following morning Inez awoke with a fever and sore throat, and had to force herself to get ready for two meetings in Helena, Montana. When she became so weak she couldn't stand, she considered quitting for the first time.

Arriving in Butte, Montana, late in the evening on October 15, Inez gave an interview at the Thornton Hotel, which was the headquarters of the Montana Equal Suffrage Association, led by Jeannette Rankin, who would later become the first woman to serve in Congress. The next morning, after an underground tour through the Leonard Mine, Inez made a luncheon speech to one hundred women at the Silver Bow Club, saying, "We are fighting for a principle and shall continue to cast our protest votes against the party which is in a position to pass the Susan

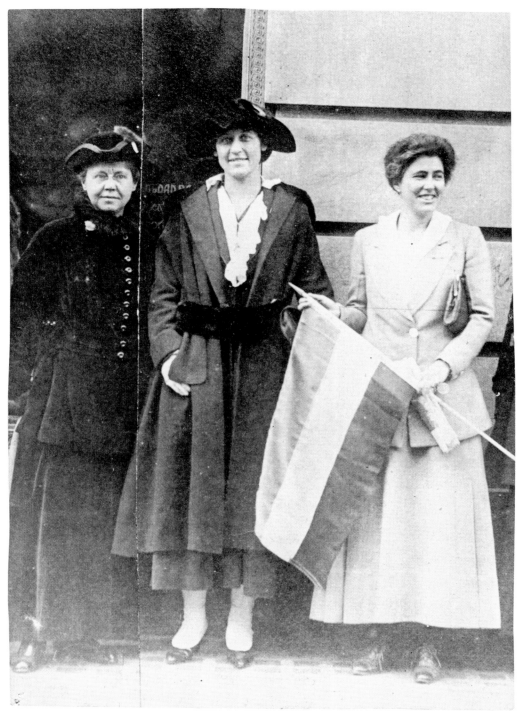

Inez Milholland, center, as she begins her last speaking trip for the National Woman's Party, October 1916

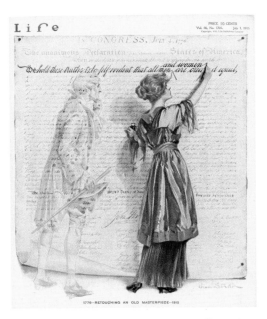

"Retouching an Old Masterpiece" depicts the suffragists' request for America to live up to the democratic ideals expressed in The Declaration of Independence. *Life Magazine*, July 1, 1915. Illustration by Paul Stahr

B. Anthony amendment, granting equal suffrage to all."[21] Inez and Vida boarded the 5:05 p.m. train and arrived in Ogden, Utah, the next morning around dawn on October 17. Doubled over in agony, Inez tripled her usual dosage of pain pills. She stood in a receiving line for more than one hundred women prior to a luncheon speech at Berthana Hall, followed by an auto parade and another afternoon speech at the Orpheum Theatre to about three hundred women and fifty men, according to multiple newspaper accounts.[22]

A short train ride then took the sisters to Salt Lake City, where Inez spoke at the Salt Lake Theatre—decorated in purple, gold, and white, the colors of the NWP—to a crowd of 1,500, with prominent society members sitting in boxes and stalls. Introduced very late, Inez tried to just answer questions, but the crowd wanted to hear her speak: "The unenfranchised women of the nation appeal to you for help in their fight for political freedom. We appeal to you to help us, for you alone have both the power and the will," she was quoted as saying in the Salt Lake City *Herald-Republican*.[23]

A day later, the Milholland sisters stopped high in the Sierra Nevada Mountains in Winnemucca, Nevada. Continuing through the state via train, they stopped briefly in Reno and motored to Virginia City, where "[p]romptly at four o'clock, the mine whistles blew, the school bells rang, and even fire whistles"[24] welcomed them. After Inez delivered a speech to five hundred residents in the street, women rushed to the town hall to register to vote. Continuing on to Silver City for another street meeting, the sunset dyed the mountains surrounding the

city a dramatic Woman's Party purple, according to a report Vida sent back to Alice Paul. The next stop was Carson City, where Inez spoke to a great crowd at The Grand Theatre. Around 1:00 a.m., the sisters started the bitterly cold drive back down the mountain to Reno.

Resting most of October 20, Inez attended an afternoon reception in her honor at the home of Mrs. George H. Taylor. That night, she gave a speech at the Majestic Theater that was "filled to overflowing," according to *The Suffragist*.[25] Some of the crowd of approximately two thousand walked the sisters to the train station to send them off to their next stop, Sacramento, California. Early the next morning, October 21, they were met at the station "by [members] of the Chamber of Commerce, . . . taken for a ride through the city, accompanied by many women in automobiles," according to another article in *The Suffragist*.[26] The all-night trip combined with the rapid descent through the Sierra Nevadas hit Inez hard, yet she mustered enough energy to deliver a luncheon speech to more than two hundred wealthy women at the Sacramento Hotel, followed by another meeting where she shared the podium with Maud Younger, a NWP lobbyist in California. The *Sacramento Union* quoted a line from Inez's speech: "We believe in government of the people, by the people, and for the people, including women."[27]

Later that day, in a campaign report, Vida noted that Inez barely had time to put on her white dress prior to being escorted to the ballroom for her speech in San Francisco, where she declared, "[President Wilson] says he must be bound by the provisions of the 1916 platform of the Democrats—provisions he wrote himself! Must he be bound by his own limitations? I ask you. Is that the reason for his refusal to see the light?"[28] *The Suffragist* reported that as many people crowded in as were turned away for the two-hour meeting of 1,500 people. Hundreds packed the platform after Inez's speech, and she remained on her feet fielding questions and shaking hands for an additional three hours.

Arriving in Los Angeles on October 23, Inez delivered her last speech to about one thousand people at Blanchard Hall, where she collapsed on stage while speaking. She returned fifteen minutes later to finish. Her final public words were, "President Wilson, how long must this go on, no liberty?"[29] Although she tried to be "indefatigable" according to the *Los Angeles Daily Times*,[30] Inez's rapidly deteriorating health forced her to stop campaigning, and she died only one month later, on November 25, 1916, at the age of thirty—a martyr of the American suffrage movement.

On Christmas Day of that year, more than one thousand people joined a procession that formed at the Library of Congress in Washington, D.C., and marched across the Capitol Plaza to Statuary Hall to pay tribute to Inez Milholland, their fallen suffrage comrade. She was the first suffragist to be honored with a memorial service in the Capitol. Maud Younger, who delivered the memorial address, stated, "Inez Milholland stood for women. She lived for women, she died for women. She is in the heart of every woman whose heart beats for tomorrow. That

tomorrow is clearer and nearer because Inez Milholland lived. We, her comrades and friends, acknowledge the great debt we owe her. In the name of all women, we accept her gift and proudly honor her triumphant death. May we have the courage and the devotion to follow where she has led."[31]

"The rights of citizens of the United States to vote shall not be denied or abridged by the United States or by any State on account of sex."
—Amendment XIX, ratified on August 18, 1920, and signed into law on August 26, 1920

The photographic essay laid out on the following pages is a tribute to the American women who paved the way for us. From courageous role models like Ida B. Wells-Barnett to countless women whose names we have yet to learn, many women from all walks of life fought for a woman's right to vote. To reflect this, I asked women of all ages and backgrounds to represent Inez, her sister Vida, and their fellow suffragists in many of the images in *Standing Together*.

I approached the digitally captured images that comprise the series in two ways. The landscape photographs depict what I imagine Inez saw with her own eyes as she traveled through the rugged West a century ago. The "autochromes" look back at history through reenactments and still lifes of moments in her journey. Auguste and Louis Lumière were at the vanguard of photography at the turn of the twentieth century, and they patented the first commercially successful color process in 1907, which they called the "Autochrome Lumière." Combining grainy potato starch and soot onto backlit glass plates, the autochrome was the most widely used process for capturing color for about thirty years. By merging their historical look with modern technology, I am attempting to bridge the gap between the suffrage movement and our current moment.

Though we have come a long way, we must recognize that we stand on a precarious ledge. The full enfranchisement of American women took well over a century. Why did it take over seventy years from the first women's rights convention in Seneca Falls, New York, for the Nineteenth Amendment to be passed? Why did the amendment only apply to white women? Indigenous American women were unable to vote in every state until 1962, and Black women could not universally cast ballots until the passage of the Voting Rights Act of 1965.

Although the *principle* of equal rights is enshrined in America's founding documents, those rights have historically been reserved for certain groups—mainly white men—and have been violently withheld from many people, most grievously from immigrants and Black and indigenous Americans. As we look back at the history of the fight for women's rights, we ought not take for granted universal suffrage. Even today, states including Texas, North Carolina, and Georgia are gerrymandering,

purging voter roles, changing voter identification requirements, and understaffing, closing or moving polling locations—all of which jeopardize voting rights.

In February 2020, Virginia ratified the Equal Rights Amendment (ERA), first introduced by the NWP in 1923, becoming the thirty-eighth state to do so and the final state needed for the amendment to become part of the United States Constitution. The proposed amendment guarantees equal rights for all American citizens regardless of sex. The ERA was sent to the states for ratification in 1972, with a time limit of seven years, which was later extended by three more years. But by 1982, only thirty-five state legislatures had ratified it. In February 2020, the United States House of Representatives voted 232 to 182 to pass House Joint Resolution 79, removing the original time limit assigned to the ratification of the ERA. The Senate must also vote for the time limit removal. And now we wait.

It is clear that we still have work to do. And as Inez would have wished, I truly hope that we all continue to stand together, shoulder to shoulder, using our voices with courage and devotion as we move "forward out of error" and "forward into light."

Notes

1. The banner is housed at the National Woman's Party Collection at the Belmont-Paul Woman's Equality National Monument in Washington, D.C.
2. The idea of the "New Woman" arose in the late nineteenth century and idealized an independent, educated, and autonomous woman not beholden to men for self-actualization.
3. Inez Milholland to Eugen Boissevain, October 6, 1916. Papers of Inez Milholland, Personal Correspondence, October 8–20, 1916. MC 308, folder 5. Schlesinger Library, Radcliffe Institute, Harvard University. All subsequent citations of Milholland's letters to Boissevain are located in this archive.
4. Ibid.
5. Ibid.
6. Ibid.
7. Milholland to Boissevain, October 8, 1916.
8. Milholland to Boissevain, October 15, 1916.
9. *The Suffragist* 4, no. 42 (October 14, 1916), p. 7.
10. Milholland to Boissevain, October 9, 1916.
11. Milholland to Boissevain, October 6, 1916.
12. Milholland to Boissevain, October 9, 1916.
13. Ibid.
14. Inez Milholland to Eugen Jan Boissevain, October 12, 1916.
15. Ibid.
16. *Spokesman-Review* (Spokane, WA), October 14, 1916, p. 8.
17. Ibid.
18. *Spokane Daily Chronicle* (WA), October 14, 1916, p. 2.
19. Ibid.
20. Milholland to Boissevain, October 15, 1916.
21. *Butte Miner* (MO), October 16, 1916, p. 6.
22. Reported in the *Herald-Republican* (Salt Lake City), October 16, 1916, p. 5; *Salt Lake Tribune*, October 18, 1916, p. 13; *Salt Lake Telegram*, October 18, 1916, p. 11.
23. *Herald-Republican* (Salt Lake City), October 17, 1916, p. 12.
24. *The Suffragist* 4, no. 44 (October 28, 1916), p. 4.
25. *The Suffragist* 4, no. 44 (October 28, 1916), p. 5.
26. *The Suffragist* 4, no. 45 (November 4, 1916), p. 5.
27. *Sacramento Union*, October 22, 1916, p. 16.
28. *San Francisco Examiner*, October 22, 1916, p. 3.
29. Linda J. Lumsden: *Inez: The Life and Times of Inez Milholland* (Bloomington: Indiana University Press, 2004), pp. 163, 174.
30. *Los Angeles Daily Times*, October 28, 1916, p. 14.
31. *The Suffragist* 4, no. 53 (December 30, 1916), p. 10.

October 4–5, 1916

New York, New York
to
Chicago, Illinois

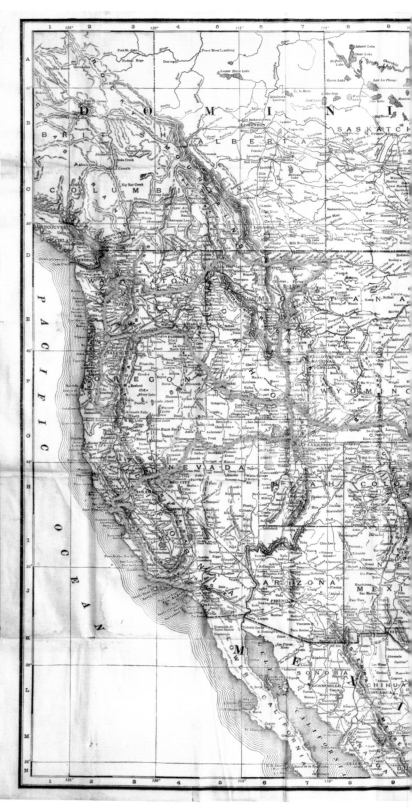

12,000-Mile Swing Through the West, 2020.
Hand-embroidery on a reproduction of the
1916 Rand-McNally New Official Railroad Map
of the United States and Southern Canada

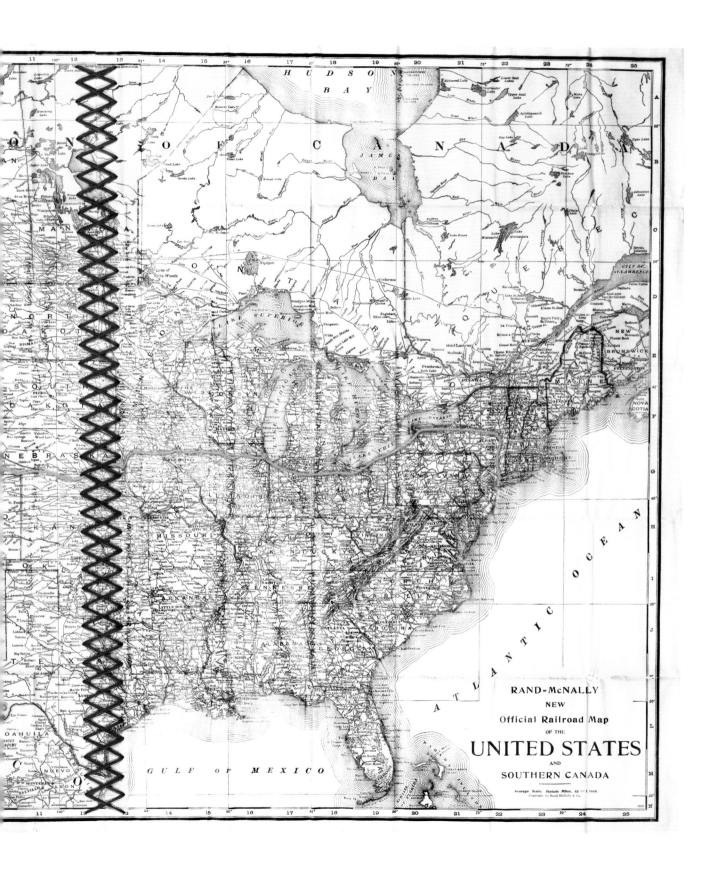

RAND-McNALLY
NEW
Official Railroad Map
OF THE
UNITED STATES
AND
SOUTHERN CANADA

Average Scale: Statute Miles, 63 = 1 inch
Copyright by Rand McNally & Co.

Ballot Box, circa 1910, 2016

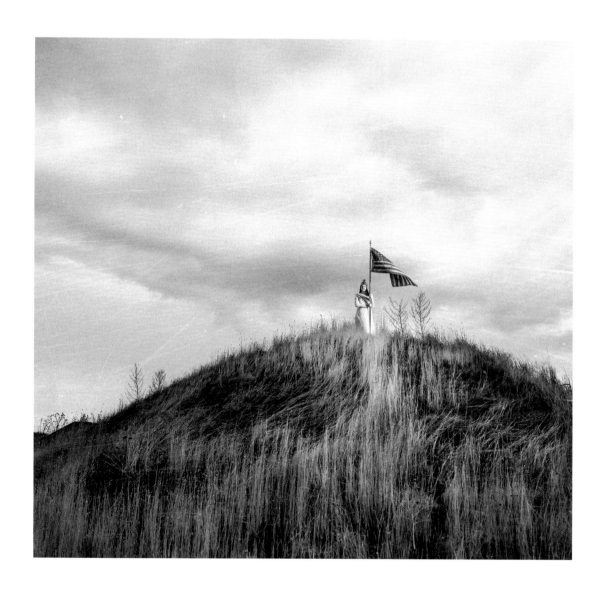

Ready for Battle, 2019

MRS. BOISSEVAIN OFF TODAY.

Her Anti-Wilson Speaking Tour Will Cover All Suffrage States.

Mrs. Inez Milholland Boissevain will start today on an anti-Wilson speaking tour, which will cover every important town in the States where women have the franchise. Mrs. Boissevain said yesterday she was the last of more than a hundred suffragists who have left New York this Summer on similar missions.

Mrs. Boissevain will make her first speech in Cheyenne, Wyo., the end of the week. She is representing the Congressional Union, a wing of the Women's Party which believes in trying to get the franchise by Federal amendment rather than by working and waiting for individual States to act. She is going alone, and once in the equal suffrage States she expects to make rear-platform speeches and to talk from automobiles as well as to deliver addresses in halls. The night before election she is scheduled to speak in Chicago, making a report of conditions in the territory she has covered.

New York Times, October 4, 1916

Farewell, Grand Central Terminal, New York, New York, 2018

Railroad Spike, 2018

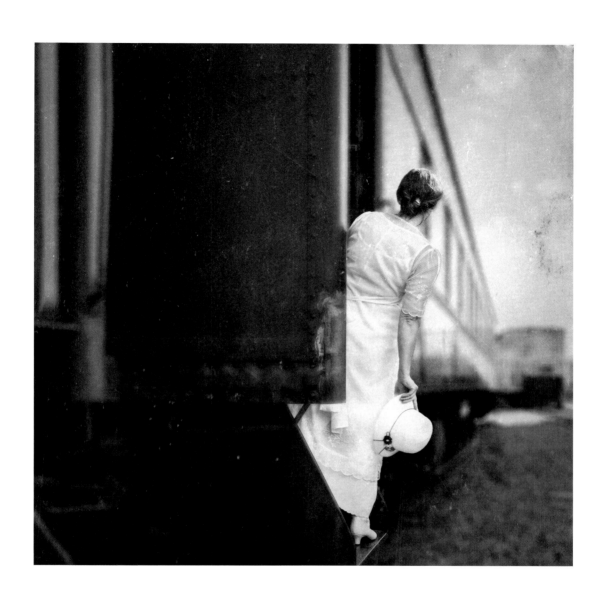

Arrival, Chicago, Illinois, 2019

Something Blue, Lake Michigan, Chicago, Illinois, 2018

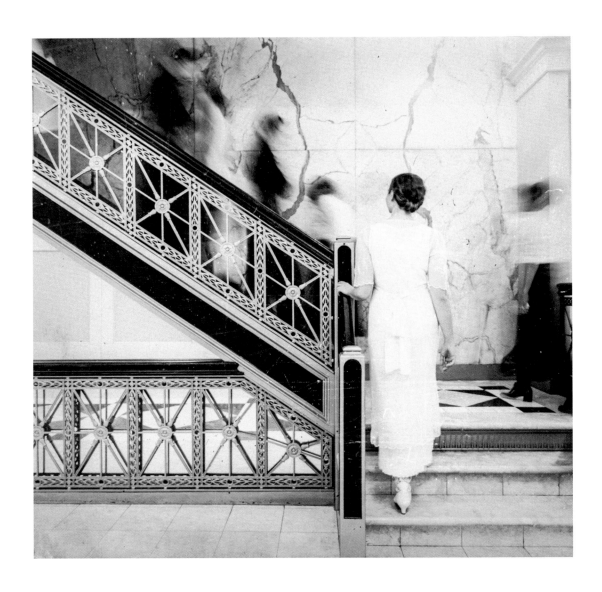

Checking In, National Woman's Party Headquarters, Stevens Building, Chicago, Illinois, 2018

Dinner and Drinks with Vida and Their Father, Blackstone Hotel, Chicago, Illinois, 2018

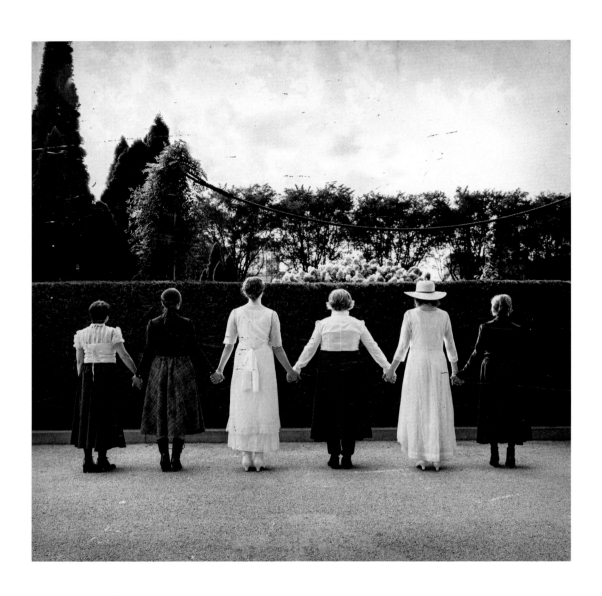

Standing Together, Grant Park, Chicago, Illinois, 2018

"*What is your answer, women with the ballot? Are you going to lick the hand that smites you like the hounds?*"

—Inez Milholland, quoted in *The Suffragist*, October 14, 1916

FIFTY-FIFTY

Mrs. Boissevain Wants All Husbands to Be Forced by Law to Divide Salary with Wives.

Mrs. Inez Milholland Boissevain.

WANTS LAW TO FORCE HUSBANDS TO DIVIDE CASH

Mrs. Inez Milholland Boissevain Warns Wives Not to Be "Clinging Vines."

FIFTY-FIFTY MARRIED LIFE.

In a Chicago visit of a few hours yesterday, Inez Milholland Boissevain of New York, who is going west to win votes away from Wilson, left behind a few recipes for domestic happiness. Incidentally, Mrs. Boissevain proposed to Mr. Boissevain, but she did not ask him to support her in the manner to which she was accustomed—or in any other manner. She earns an excellent living as an attorney.

Substantially, Mrs. Boissevain's advice to women seeking connubial happiness is this:

Don't be a clinging vine.

Don't let friend husband order you around. It's bad for him. It gives him an exaggerated opinion of his importance, as those who are strong to command at home are usually taking all the orders elsewhere.

If husband's love seems to be growing cold, go out and get a job. Pay the bills —that is, your share of them. Take him out to dinner. Meet him half way, and make him do the same for you.

If you prefer to manage his household, accept in payment half of his salary. You are worth it.

Not at This Plane Yet.

Mrs. Boissevain believes that society has not yet reached the plane where the last provision can be fulfilled without the aid of laws.

"The work a woman does at home," she said in an interview at the Blackstone hotel, "is so dignified and so important that it ought to be paid for. Except for the services of his wife in the home, a man would have to employ a cook, a nurse, a doctor, a bookkeeper, a scrub woman, and a chambermaid. The wife who manages the household should receive half of her husband's income.

Should Force Division.

"Individual agreements to that effect will not hold and cannot be made to apply to all families. Every state should have a law requiring men to divide their incomes with their wives. All the law requires now is that a man keep a roof over the woman to whom he is married.

"It is customary for him to say: 'Here, Mary, is $5 for you.' Whatever money she gets comes from the husband only because he is moved to give it to her. Too many women take the attitude that he earns the money and that it is all his. They do not put the proper value on their own services in the house.

"It is better for a woman to be an independent wage earner. There is no relationship so delightful as when both husband and wife work and contribute toward the expenses of the household on equal terms. Love is kept alive. It is not smothered in unorliousness or domesticity."

Why They Escape.

The ease with which women offenders escape punishment, according to Mrs. Boissevain, is due to a subconscious feeling on the part of male jurors that a woman ought not to be punished by a law which she has had no part in making.

"It is almost impossible to convict a woman, even when she is guilty of such crimes as murder and perjury," said Mrs. Boissevain. "There is a subconscious feeling that it is a dirty deal to penalize a woman when she has had no voice in making the laws under which she is convicted. But that is a bungling attempt at justice."

Calls It Childlike.

Mrs. Boissevain said that the women who are allying themselves with the political parties at this time, when full suffrage has not been granted, are doing an act that is childlike, impolitic, and traitorous to the cause of women. She will speak in all the states where women vote, and will urge the women to vote against the Democratic party because of its attitude towards suffrage.

"We are not rooting for Mr. Hughes," she said, "although we are making thousands of votes for him. We do not tell the women to vote for Hughes, but we show them that a vote for Hughes is two votes against Wilson."

She left at 10 o'clock for Cheyenne, where she will make her first speech. A big woman's massmeeting will be held in Chicago the night before election, at which she will speak on her return.

'DON'T WORRY' SMOKER DIES

F. Marion Smith, Bridegroom at 71 and Who Smoked All He Wanted, Passes Away.

"Don't Worry" F. Marion Smith, who became a bridegroom at the age of 71, died yesterday at 4627 Calumet avenue. He was 73 years old.

When Mr. Smith married Mae Harriet M. Orr, his landlady, and thirty-two years his junior, he declared his health was as good as a man of 40. His chief slogan in life was "don't worry," and he declared he smoked as much as he cared to and drank all the coffee and ate all the food he desired.

He was western manager for the Huntley Manufacturing company.

miliation abroad and national abasement at home."

The administration, he asserted, has made the mistake of trying to make present conditions fit old laws instead of making new laws to fit present conditions. What is needed now, he said, is the nationalization of business, against which the nationalism of the Wilson administration inveighs, and the placing of all interstate carriers under the "exclusive control of the national government."

Any plan of national preparedness, he said, that did not embrace the railroads was faulty.

"The era the nation is just entering," he added, "will be known to history as the age of the builders.

"The administration boasts of 'constructive laws.' Where did they come from?" A Republican. 'Who was the author of the child labor law?' A Progressive and Republican. 'Who proposed and framed the tariff commission law?' The same man who originated national child labor legislation. Who advanced the idea of a national trade commission? An eminent American business man—a Progressive and a Republican."

Declares for Protective Tariff.

Mr. Beveridge declared unconditionally for a new protective tariff to meet the revolutionized economic conditions in Europe.

"Even free traders," he said, "cannot fail to see the necessity for this, at least until we can ourselves work out the organization of American industries and business on modern lines. If we never before had a protective tariff we should be forced to create one now.

"Our so-called prosperity today is sectional. It appears only in spots. It is spotted prosperity—spotted and stained. Wherever the war has directly reached the sources of production business is good; elsewhere, business is bad. We must have a tariff that will protect all parts of the country alike in peace as well as in war, and make our prosperity genuine, steady, and national."

Americans in Mexico.

Mr. Beveridge declared that thousands of Americans, relying on the traditional history of the nation, went to Mexico under a guarantee of safety to invest their money and to labor there in the working out of their life plan, and they have seen an American administration abandon them, men and women, to outrage and murder, to pillage and destruction, and American rights subjected to insult and mockery.

"There are only two same courses to take in Mexico—to go in and restore order to the anarchy maddened creatures of that country or to keep out and leave them to their mutual destruction. But the administration did both and neither. If to safeguard American lives is a duty, then the administration fled from that duty. If to protect American property is an obligation, the administration repudiated it. It allowed powder and guns and all the implements of warfare to pour across the border, then closed the embargo on arms, then raised it again, and closed and raised it once more.

Killed by American Guns.

"Every American citizen and every American soldier that has been shot to death was killed with an American bullet fired from an American rifle. Murder, arson, loot, rapine, desolation are the fruits that have ripened under the policy of watchful waiting. We have not respected Mexican rights and yet we have not safeguarded American rights. And the administration that permitted this condition to develop and that is largely responsible for it tells us that it will not lift a finger to change it. Yet we hear unctious platitudes about guiding mankind aright and laying upon unruly nations the restraining hand of a superior brotherhood. If we turn our backs upon the practical duty at our doors, how can we realize impracticable idealism in distant lands?"

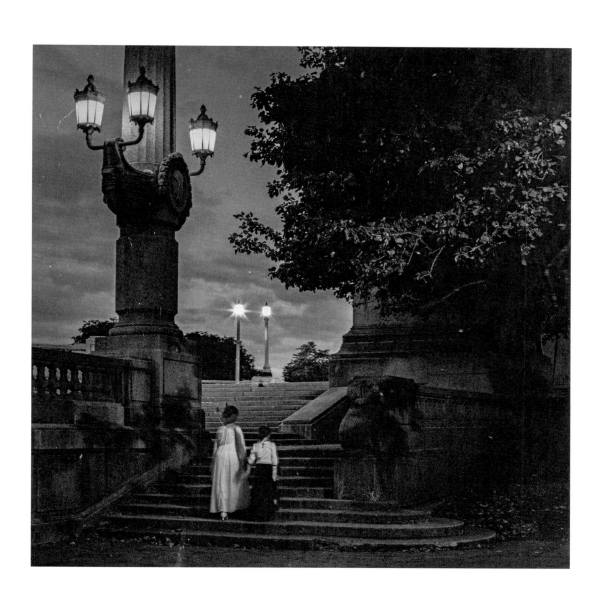

The Campaign Begins, Chicago, Illinois, 2018

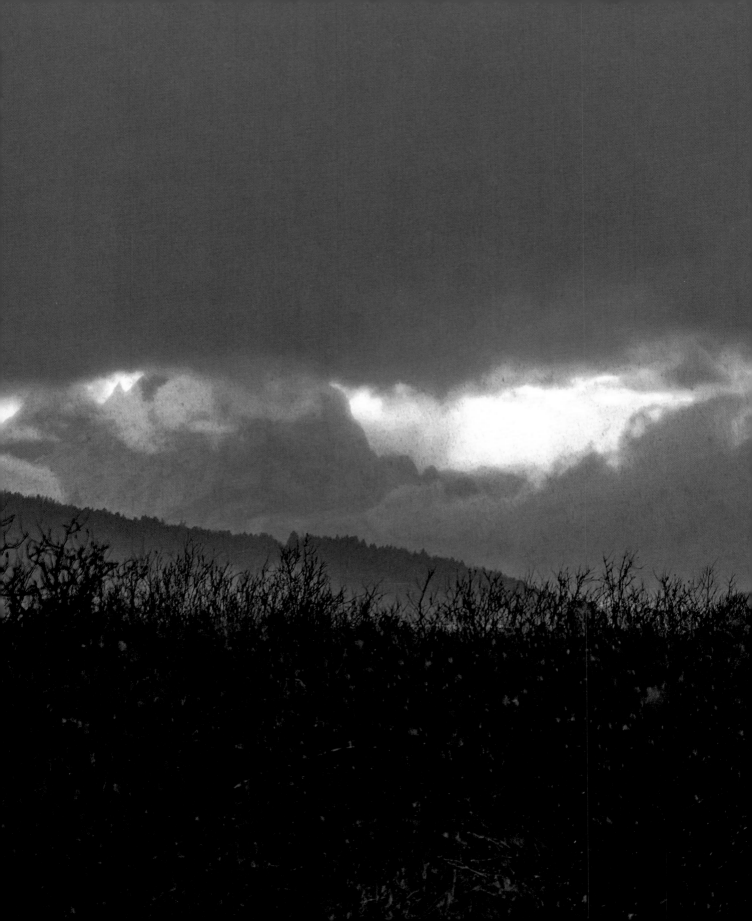

October 6–7, 1916

Chicago, Illinois
to
Cheyenne, Wyoming

"It is impossible for any problem that confronts the nation today to be decided adequately or justly while half the people are excluded from its consideration. If democracy means anything it means a right to a voice in government."

—Inez Milholland, quoted in the *Casper Daily Tribune*, Wyoming, October 18, 1916

Table of Matters, Plains Hotel, Cheyenne, Wyoming, 2019

Union Pacific Passenger Depot, Cheyenne, Wyoming, 2019

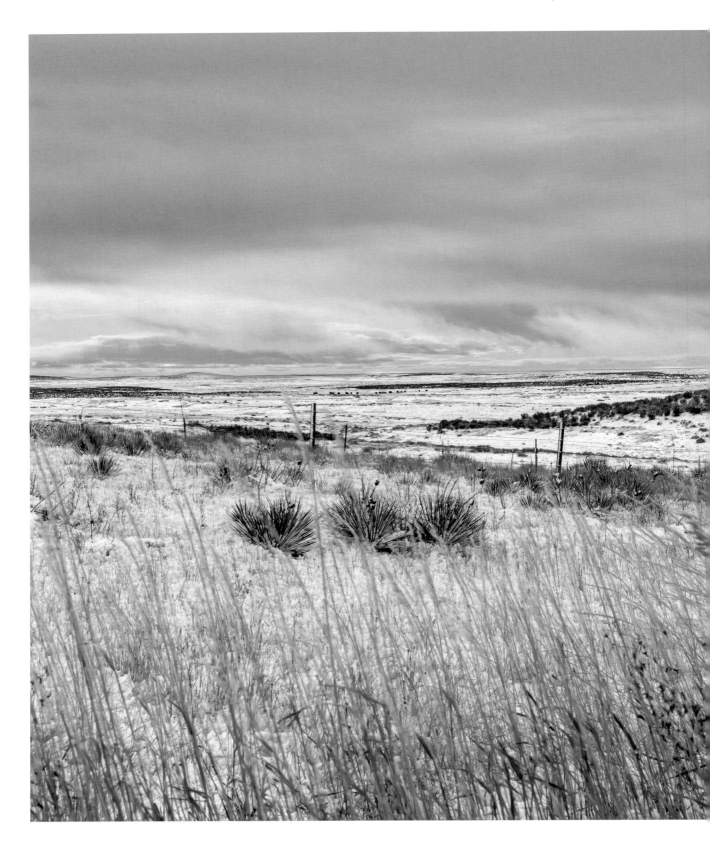

Fence Line, Wyoming, 2019

SUFFRAGE BEAUTY WHO IS TO DELIVER ADDRESS IN CHEYENNE NEXT SATURDAY

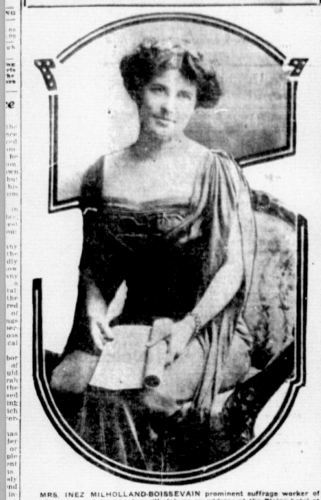

MRS. INEZ MILHOLLAND-BOISSEVAIN prominent suffrage worker of the Congressional Union who will deliver an address at the Plains hotel at 3 o'clock next Saturday afternoon. She will be accompanied by Mrs. Harriet Stanton Blatch who also will speak. After the addresses Mrs. F. E. Warren and Mrs. N. S. Thomas will introduce the ladies present to the speakers. Mrs. Boissevain and Mrs. Blatch will be in Cheyenne all day Saturday.

Wyoming Tribune, Cheyenne, October 6, 1916

WOMEN APPEAL FOR AID OF WOMEN TO ELECT CHAS. E. HUGHES

MRS. BOISSEVAIN AND MRS. BLATCH ADDRESS LADIES AT PLAINS HOTEL.

(By Veda Milholland.)

We have just come from the highly successful suffrage meeting organized by that little live wire, Margery Gibson Ross. The Plains Hotel was in gala attire Congressional Union banners tellingly inscribed, were draped artistically and convincingly within view of everyone. The meeting was announced for three o'clock but long before that time groups gathered on the mezzanine balcony outside.

One of the characteristics of this gathering was that the young married women and college women were particularly in evidence. Among some of the notable women were Mrs. Francis E. Warren, wife of Senator Warren of Wyoming, Mrs. Nathaniel Thomas, wife of Bishop Thomas of the Episcopal church in Wyoming, Mrs. Herman Gates, wife of State Treasurer Gates, Mrs. William Reno, wife of the Fort Russell commander, Mrs. Galen Fox, Mrs. Harry Riner, Mrs. Fred Warren, Mrs. Wallace Bond, Mrs. William Dubois, Mrs. C. L. Hinkle, Mrs. T. Blake Kennedy, wife of the secretary of the Republican State Central committee, Mrs. W. E. Mullen, Mrs. Fred Boice, Mrs. William Kinkead, Mrs. Mentzer, Mrs. Frank Gleason, Mrs. Albert Walton, Mrs. Frank Bon, and Misses Eleanor Clark and Alice Downey.

The committee on arrangements were: Mrs. Cyrus Beard, wife of Justice Beard of the State Supreme Court, Mrs. Hilliard Ridgley, Mrs. E. W. Clafcke, Mrs. Archie Allison, State President of the W. C. T. U., Mrs. D. R. Kinports, Mrs. Ashley Gleason, Mrs. Robert Forsythe, Mrs. C. L. Beatty, Mrs. W. L. Whipple, Mrs. W. E. Stone, Mrs. Theresa Jenkins, Mrs. W. R. Chaplin and Mrs. E. J. Kelly and Mrs. Clyde Early.

After some music the meeting was called to order by a most competent chairman, Miss Mildred McIntosh. Just here I must be personal and express the real thrill I received at being, for the first time, in an audience composed almost exclusively of women voters. Maybe it was only my imagination but it seemed to me, the mere fact of being citizens of this great republic gave to these women a poise and a political sagacity that I have never seen in any group of non-voting women. Inez Milholland

Wyoming Tribune, Cheyenne, October 10, 1916

LICAN, FRIDAY, OCTOBER 27, 1916

WOMEN OUTLINE POLITICAL VIEWS

Strong Appeal to Western Woman to Help Unenfranchised Women of East

"Women for women and therefore not for Wilson," is the substance of the official appeal now being carried through the West by Inez Milholland Boissevain.

This famous federal suffrage speaker is being received by enthusiastic crowds. Thousands of people are coming from miles around to hear the powerful and attractive speaker, noted the nation over for her personal charm as well as for her oratorical ability. Halls and theaters are being filled to the limit wherever Mrs. Boissevain appears, and overflow meetings have to be arranged to take care of the crowds.

Mrs. Boissevain is the beautiful flying envoy of the woman's party, carrying over western mountain, plateau and plain, the final appeal of the eastern women to the voting women in the equal suffrage states for support in the fight for nation-wide woman suffrage.

Large and enthusiastic crowds greet Mrs. Boissevain as she presents her appeal with proper formality and ceremony to the accredited official or officials of the woman's party in the state visited. At Cheyenne, for instance, the first place visited by Mrs. Boissevain after she left Chicago, the appeal for help for the unenfranchised women was accepted by Miss Mildred McIntosh, Cheyenne chairman of the woman's party, acting for Dr. Frances M. Lane of Cody, state chairman, who has arranged to have the appeal brought to every woman voter in every county of the state.

"It is impossible," says the appeal in part, "for any problem that confronts the nation today to be decided adequately or justly while half the people are excluded from its consideration. If Democracy means anything it means a right to a voice in government.

"Women are as deeply concerned as men in foreign policy. Whether we shall have a civil or militaristic future is of deepest moment to us. If things go wrong we pay the price in lives, in money, in happiness. We are concerned about what sort of tariff we shall have. If the cost of living goes up, we as housekeepers, are the ones to suffer.

"We are deeply interested in the question of national service. We know, and must help to decide, whether our sons are to be trained to peace or war.

"To decide these questions without us, questions that concern us as vitally as they concern man, is as absurd as would be an attempt, to exclude the mother from influence in the home or care of her family.

"We say to the government:

"'You shall not embark on a policy of peace or war until we are consulted.

"'You shall not make appropriations for the buildings of ships and engines of war, until we, who are taxed for such appropriations, give our consent.

"'You shall not determine what sort of national defense we shall have, whether civil or military, until we co-operate with you politically.

"'You shall not educate our children to citizenship or soldierdom without our wisdom and advice.

"'You shall no longer make laws that burden us with taxes and high prices, or that determine how our commodities shall be prepared and by whom, or that regulate our lives, our purchasing capacities, our homes, our transportation and education of children, until we are free to act with you.'

"This is our demand.

"This is why we place suffrage before all other national issues. This is why we will no longer tolerate government without our consent. This is why we ask women to rise in revolt against that party that has ignored the pleas of women for self-government, and every party that ignores the claims of women, until we win.

"Women of these states, unite. We have only our chains to lose, and a whole nation to gain. Will you join us by voting against President Wilson and the Democratic candidates for Congress?"

As far as possible every one of the more than 4,000,000 western voting women will have addressed to her a copy of the appeal "To battle for her fellow women who are not yet free."

Choose Hughes!
"The man who's unafraid
To safeguard American trade."

It would be interesting to have Mr.

Kemmerer Republican, Wyoming, October 27, 1916

Snow Fall, Wyoming, 2019

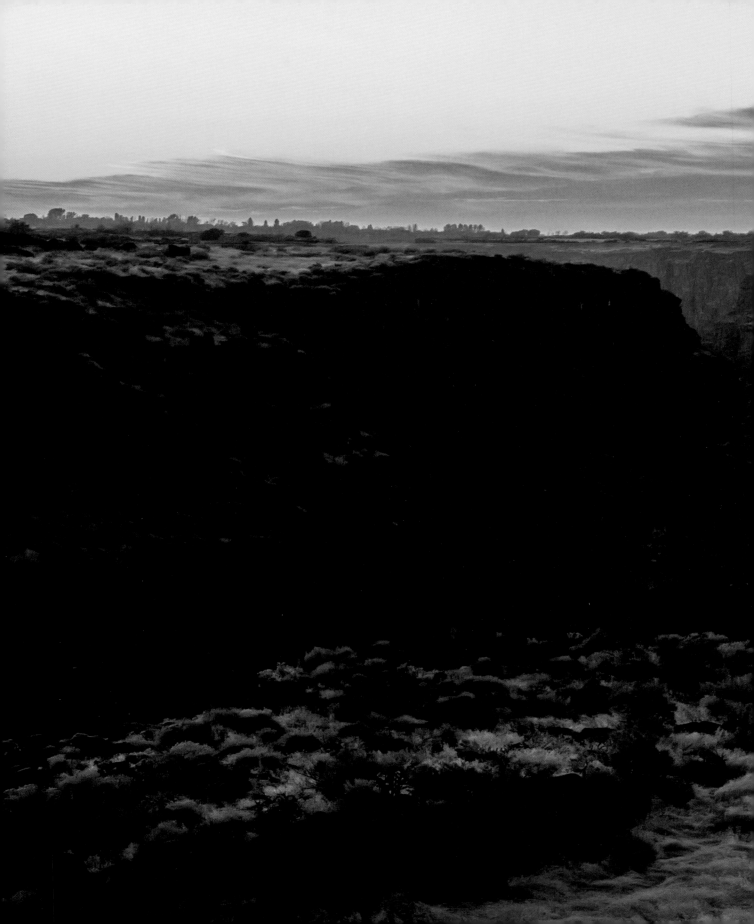

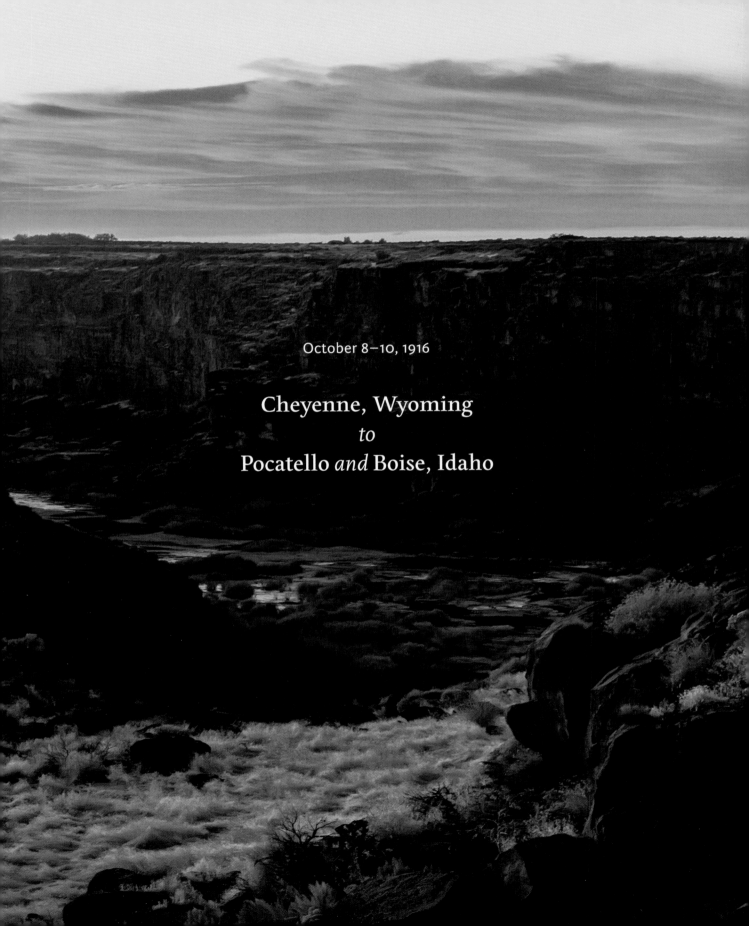

October 8–10, 1916

Cheyenne, Wyoming
to
Pocatello *and* Boise, Idaho

"I just saw a little calf suckling
its mother. That reminds me . . .
I want to have a baby."

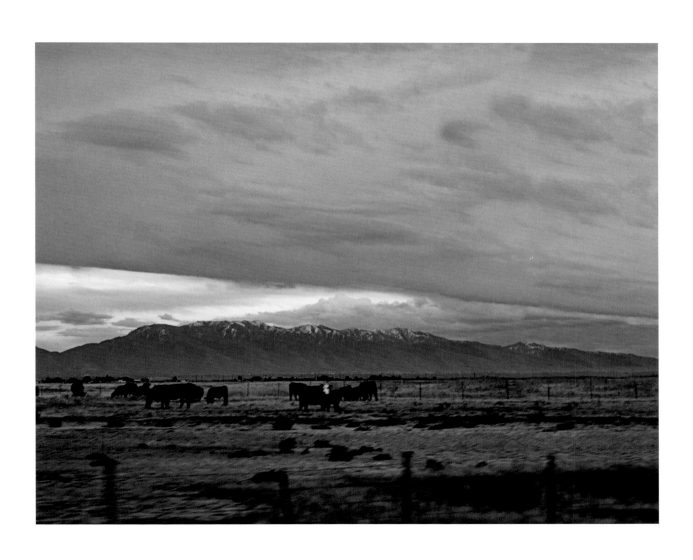

Contemplating a Family, Wyoming, 2018

Hotel Yellowstone, Pocatello, Idaho, 2019

Oregon Short Line Passenger Depot, Pocatello, Idaho, 2019

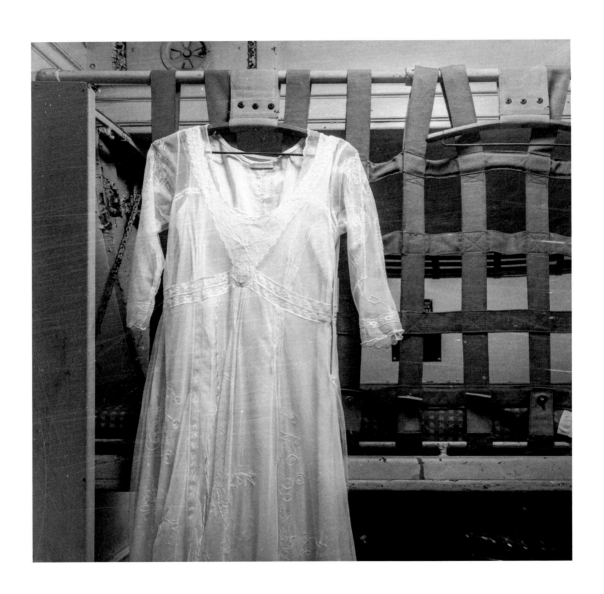

Suffrage Dress, 2019

A Gift of Flowers, train platform, Glenns Ferry, Idaho, 2019

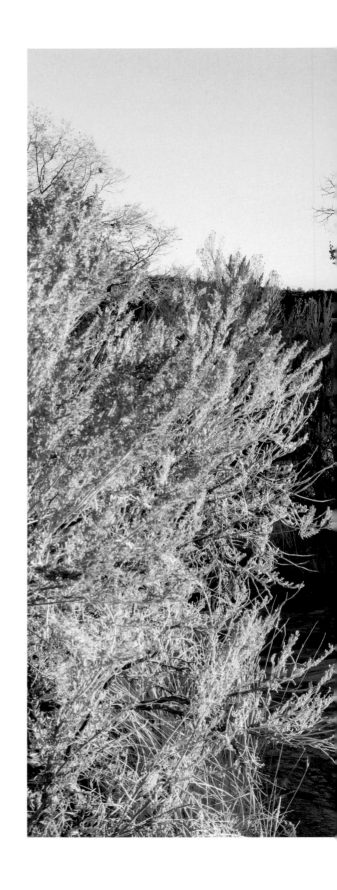

Golden Light, Idaho, 2019

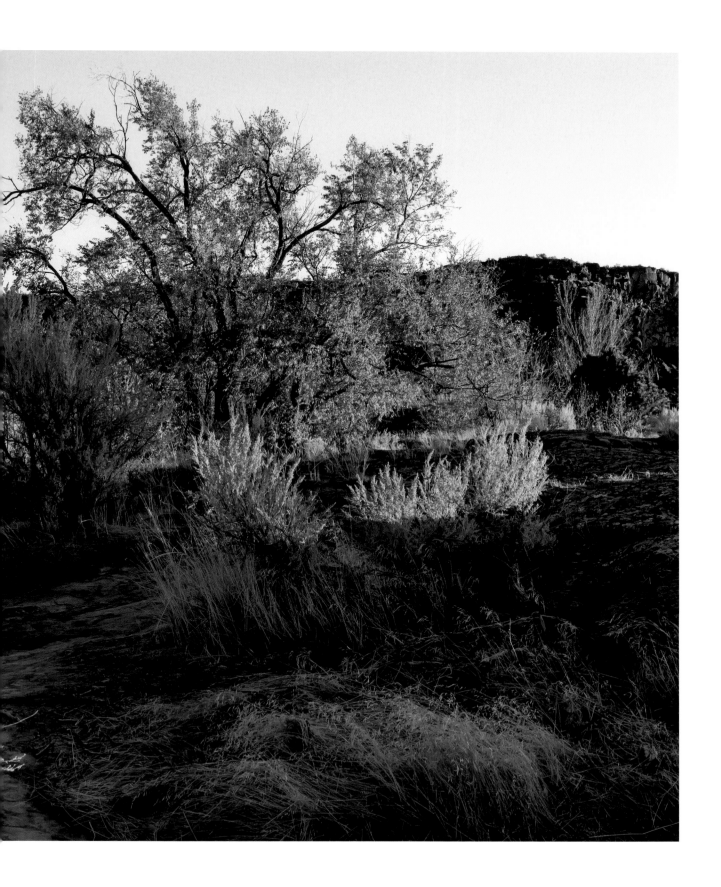

*"We are going through a . . . country
with pretty undulations of alkali and
some lovely twisted goose bushes."*

—Inez Milholland, letter to her husband, Eugen Boissevain, October 8, 1916

Wildflowers among the Rocks, Idaho, 2019

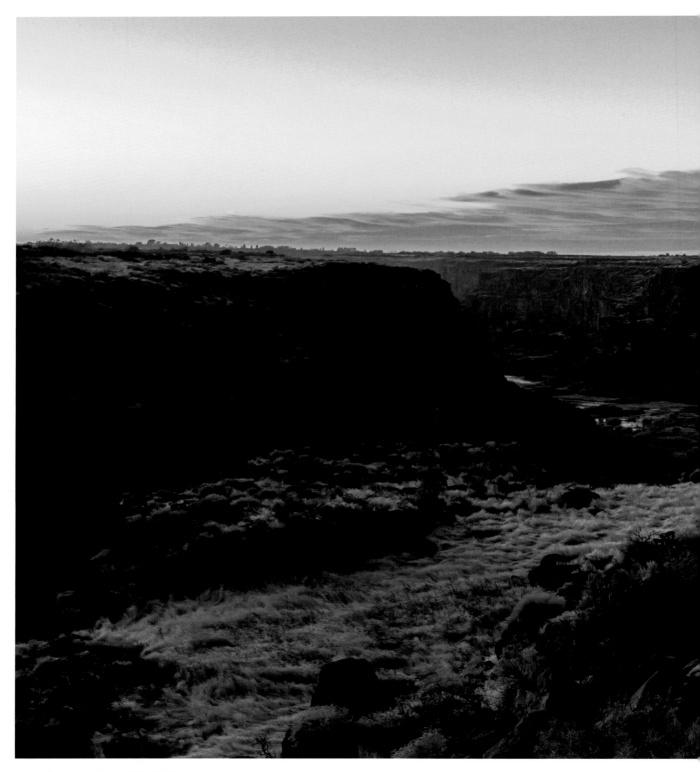

Snake River, near Twin Falls, Idaho, 2019

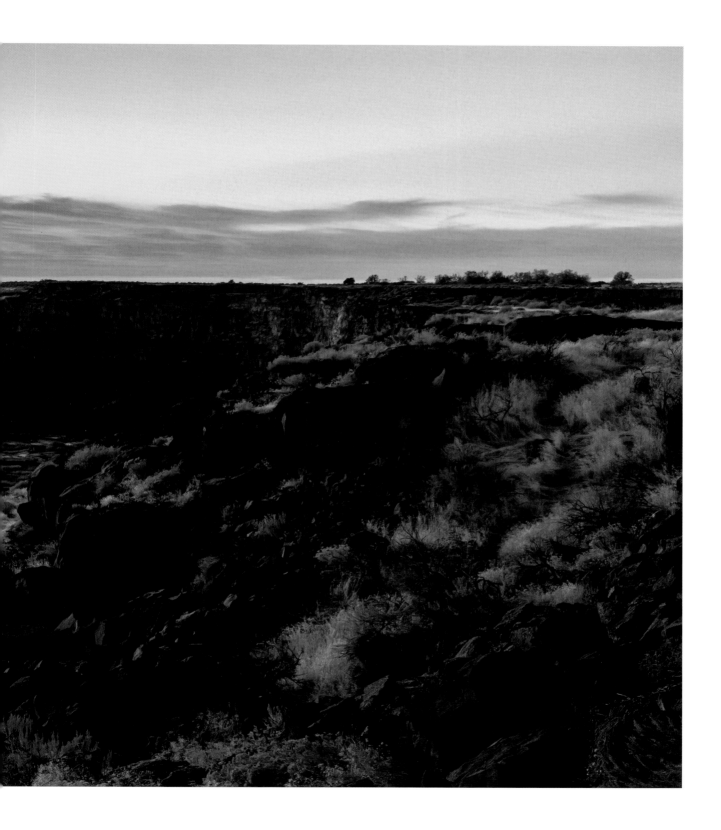

Pinney Theatre, Boise, Idaho, 2019

FAMOUS WOMAN
SPOKE AT POCATELLO

Mrs. Brandon of Kemmerer Who Heard Miss Milholland, Writes Local Friend of Meeting

A great deal has appeared of late concerning the trip of Miss Inez Milholland of New York, who is touring the West in the interest of the woman's party. After addressing several meetings in Wyoming, Miss Milholland appeared before an assemblage of Idaho women at the Yellowstone hotel in Pocatello last Monday morning. Included in the noted woman's audience was Mrs. C. Watt Brandon of Kemmerer, and to a local friend Mrs. Brandon gives the following account of the meeting:

"It was my pleasure last Monday morning to hear the address given in the Yellowstone hotel parlor by Mrs. Boussevain, or Miss Inez Milholland, as she is more familiarly known, and to meet her and Miss Eleanor P. Barker afterward.

"Mrs. Boussevain is a most interesting, convincing and logical speaker and she made a most favorable impression on the crowd of woman who greeted her, and her personal appearance was not the least to be observed. As a woman of immense wealth, splendid education, accomplished, one of magnetism and stately beauty, yet withal a womanly woman, she is one to win the hearts of all who were so fortunate as to hear her. She was very plainly dressed, no jewelry of any kind, but a small timepiece hung on a dark ribbon around her neck, tucked in the folds of her snowy blouse; not the vulgar display of wealth one ofttimes sees, especially those of newly acquired riches. Common sense was plainly written in every feature.

"The suffrage question was not the only one discussed, but the abuses given by the Democratic party, and she impressed on ther hearers the fact that now was the time to work, for in some states the question cannot come up again for five, others for seven years, and that the only issue to concern the woman was the suffrage question; that women stand up for their rights, stating that 'taxation without representation was most tryannical,' and in organization was their only relief. She said: 'some say the Democratic party or President Wilson kept us out of war. What war, on what grounds and with whom? I'm sure I don't know.'

"The Adamson bill was scored as a purely political measure, to gain the votes of the railroad boys.

'She concluded by saying, 'vote any way you please, just so you vote against the Democratic party. Any Democrat is a good one to vote against, as the party had done nothing for suffrage, and Wilson himself had seven times refused to aid the women.

"I regret that the women of Kemmerer are unable to hear these speakers.

"Mrs. Sara Bard Field will speak in Pocatello Friday evening and I plan to hear her, as she is considered a most wonderful speaker. I understand that the Montpelier people gave Miss Milholland quite an ovation as the train passed through that place, calling her to the rear of the train, from which she spoke for a few minutes."

Kemmerer Republican, Wyoming,
October 13, 1916

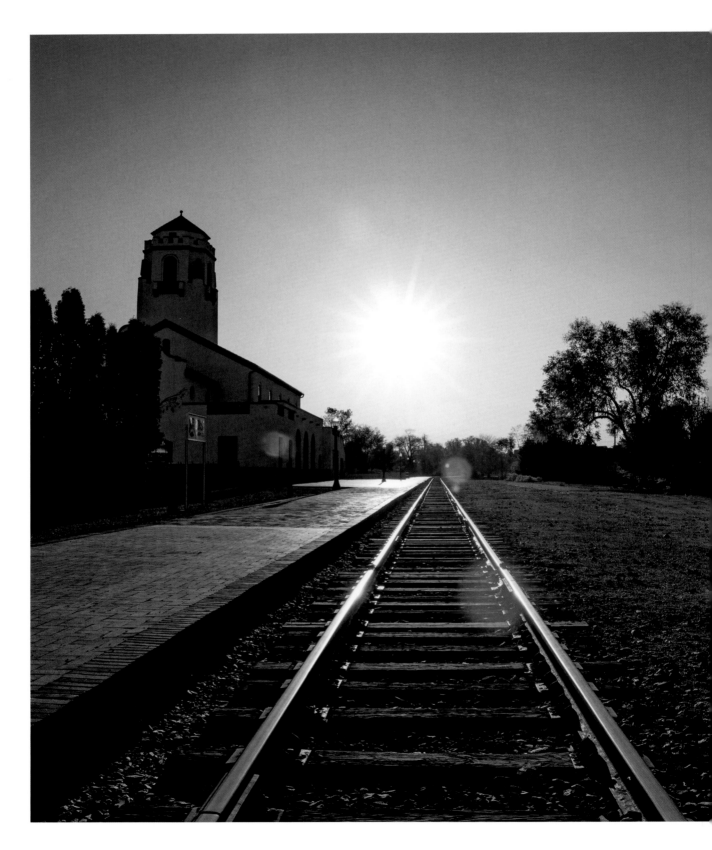

Boise Depot, Idaho, 2019

Leaving the Valley, Idaho, 2019

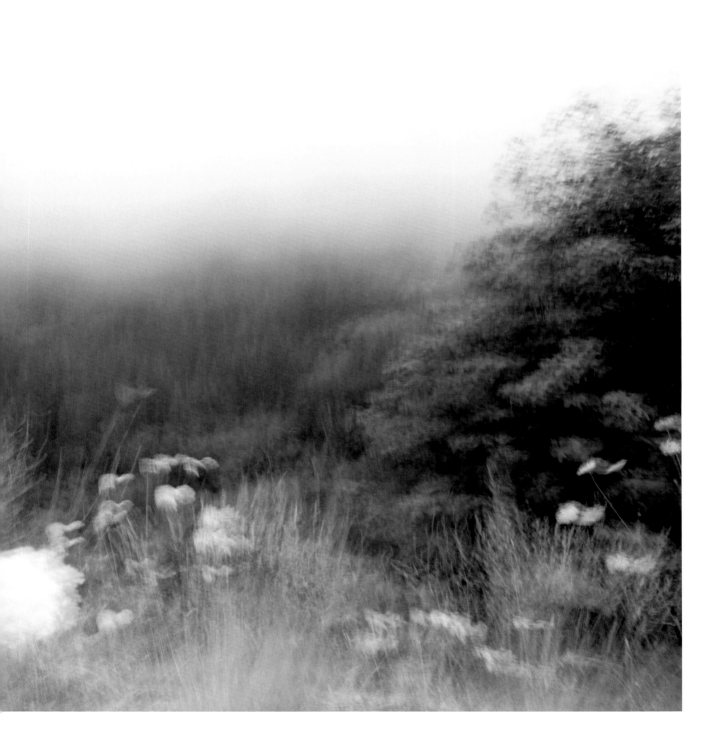

Here's Sisterly Gossip About Mrs. Boissevain, the Suffrage Speaker

Beautiful Visitor, Worn by Trip, Lets Miss Vida Milholland Give Interview.

HUSBAND TELEGRAPHS BEFORE EACH MEETING

Although usually in splendid health, Mrs. Inez Milholland Boissevain was tired and almost ill upon her arrival in Boise Monday evening and sent word she would be unable to see a reporter before the evening meeting at the Pinney. She had left Pocatello at 11 o'clock on the fast mail that carries no diner and so had been obliged to forego luncheon. Upon her arrival at the Owyhee she ate a light dinner and went immediately to her room, where she remained until the hour of the meeting.

Her sister, Miss Vida Milholland, who accompanies her, appeared, however, and asked if she might take her sister's place to be interviewed.

"I know a good deal about her," she said, laughingly, "and perhaps I can tell you what you want to know. Sister and I are both crazy over the west. This is my first trip. I had not even seen Chicago before, and is is maddening to rush through as we are doing, with hardly a glimpse of these attractive cities. We got in to Boise just in time to see some beautifully kept streets, a lot of charming trees and then darkness came on and we leave before daylight tomorrow, without another glimpse of this lovely little city. However, I am coming west again. I am a concert singer, and I am going to arrange my own itinerary and it will be one that will give me a chance to see the glorious west."

"Is a Real Lawyer.

Asked if her sister still maintained her law practice since her marriage three years ago, Miss Milholland said:

"Yes, indeed, she is the same business-like business woman. They have a charming home out of New York and she and her husband go into town together on the train every morning and return at night to their cozy home for dinner. Sometimes when they are not quite so pressed for time, they motor in, but not regularly. Mr. Boissevain is a typical business man and my sister is the only woman member of the big law firm of Osborn, Lamb and Garvan. It was a genuine sacrifice of business to her to leave at this time, but she felt that this was the one time for a grand, final attempt, and she was willing to sacrifice a good deal to make this attempt to secure the votes which would help the passage of the federal amendment.

Held Meeting in Graveyard.

"You know," said Miss Milholland, "my sister has been an ardent advocate of equal suffrage since her college days. You have perhaps read how terribly she embarrassed President Taylor, of Vassar when she arranged, in her sophomore year, a suffrage meeting on the college campus, and he insisted on her calling it off not wishing to have the college identified with anything of the kind, and she had to hold it in the graveyard nearby. She is thankful she has lived to see an entirely different spirit toward suffrage at her alma mater, which is now a help rather than a hindrance to the work.

"I spoke of the sacrifice my sister was making in her legal work on this trip. She is making a personal sacrifice as well. Although married for three years, her husband and she are still as affectionate as ever. He, so far, has sent her a telegram which has reached her just before she has spoken at each meeting and you would think that telegram contained some exceedingly important news the way she grabs it and reads it."

Crowd at Pocatello.

The meeting at Pocatello at which Mrs. Boissevain spoke was so crowded, according to Miss Eleanor P. Barker, that fully 200 men stood on the outside, having been obliged to give their places to women. Just a minute or two was spent at Glenns Ferry, the train being late, but a large number had waited, and she spoke from the rear of the coach. She leaves this morning for Portland where she speaks this evening and from there she goes to Spokane. It is her aim to speak at least twice in each of the 12 enfranchised states, while on this five weeks' tour.

Mrs. Boissevain's Idaho meetings were arranged by Mrs. Muhse and Miss Eleanor P. Barker, of the Woman's party, the latter accompanying her to Pocatello and Boise.

GERMANY FLOUTS U. S., SAYS BRITISH EDITOR

Old Issues Raised in a Fresh and Grave Form, Is View of London.

LONDON, Oct. 10. — Under the heading "Germany Flouts the United States," the Daily Mail says the old issues between those countries have been raised in a fresh and grave form. After quoting the protest of the United States to Germany for the sinking of the Lusitania, in which it was stated that it was a breach of the laws of war to leave the crew and those on board a submarined ship "to the mercy of the sea in her small boats," the Daily Mail says this was precisely what was done in the case of the British steamer Stephano.

"If wholesale murder was not permitted almost within range of American guns," says the newspaper, "it was owing to the action of United States destroyers, which saved hundreds of lives. That the American seamen showed the greatest energy and efficiency in aiding passengers and crew will not surprise the people of this country, who know the United States navy as a great service with splendid traditions."

The Daily Mail predicts prompt action by the United States with regard to the operations of German undersea craft near American shores, "because of American communications being cut and American exports being sent to the bottom of the sea."

The Daily Telegraph says: "The most important result of Germany's latest submarine policy is that once more a delicate situation has arisen between the United States and Germany. If no lives have been lost as a result of these torpedoings off the American coast, that is due to good luck and not to the good will of the U-53."

FAIRBANKS PLEADS UNITY

Appeals to Washington Voters to Forget Differences; Raps Spotted Prosperity.

SPOKANE—An appeal to the Republicans of Washington to "forget the little overturning of four years ago, the little difficulty when we fell out and the Democrats fell in," was made here Monday night by Charles W. Fairbanks, Republican vice presidential candidate, who completed his tour of Washington with a speech in the armory.

Fairbanks took up the Democratic platform of four years ago and questioned among other planks the one-term plank which, he said, "the Democrats are now trying to repudiate. But I do not think that it will matter much, for the people are going to hold the Democrats to their one-term plank."

Another plank of the Democratic platform which he said the people saw repudiated was the one favoring a reduction in the cost of living.

Fairbanks accused President Wilson of laying the foundation of industrial unrest and said that when the Democrats went into power millions of men went out of work. The Democratic prosperity, he declared, was sectional and in favor of the south and that "a party that is sectional is too small to govern this country."

The prosperity of the country at present, Fairbanks attributed to the European war. "It is a leopard prosperity," he said, "the kind that exists in spots. It is a prosperity made by orders for munitions and it is a prosperity that the Republicans do not want.

"When the war ceases the orders will stop and then the battle between wage workers of Europe and the United States will begin. It is then that a protective tariff favored by the Republicans should be in effect."

JAPS CROWDING CHINA

Alarm Felt by Republic's Newspapers Over Nipponese Demands.

PEKING — The Chinese press expresses alarm at the insistent manner in which Japan is pressing its demands made in consequence of the recent clash between Chinese and Japanese troops at Cheng Chiatung, Manchuria. The newspapers voice fear that the new Japanese cabinet will adopt an aggressive attitude.

Baron Hayashi, the Japanese minister, visited the foreign office Monday and discussed with Chen Chin Tao, Chinese minister of finance, the Cheng Chiatung demands. Baron Hayashi emphasized Japan's demands.

The Milholland Sisters, 2019

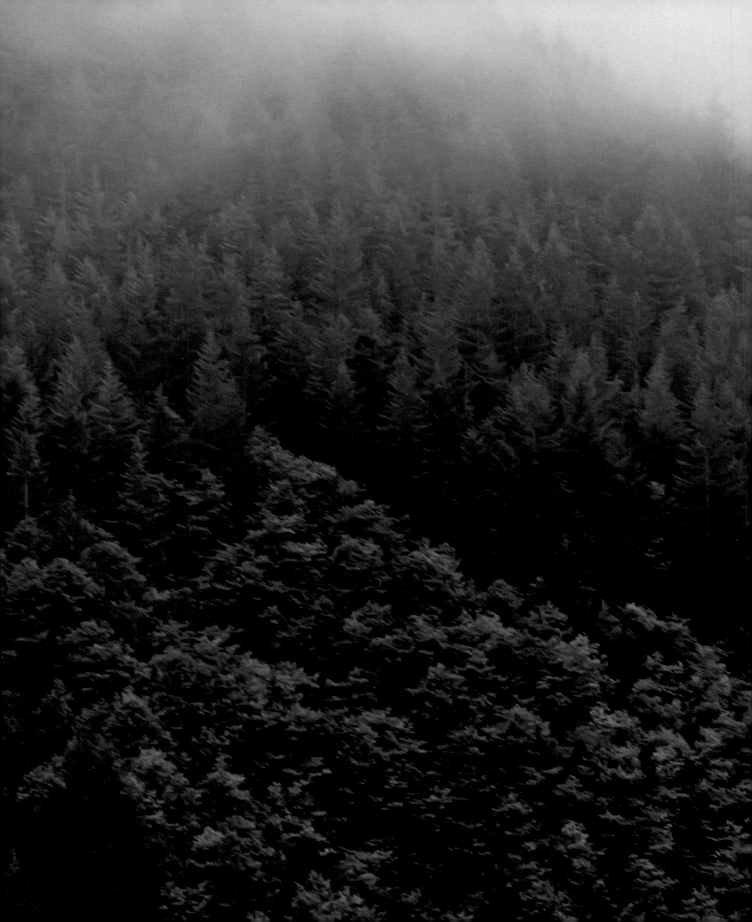

October 10–11, 1916

Boise, Idaho
to
Medford *and* Portland, Oregon

"Unless the women are satisfied with the world as it has been in the past, you must assert yourselves. Are you satisfied with the world? I am not."

—Inez Milholland at the Multnomah Hotel, Portland, quoted in the
Oregon Daily Journal, October 11, 1916

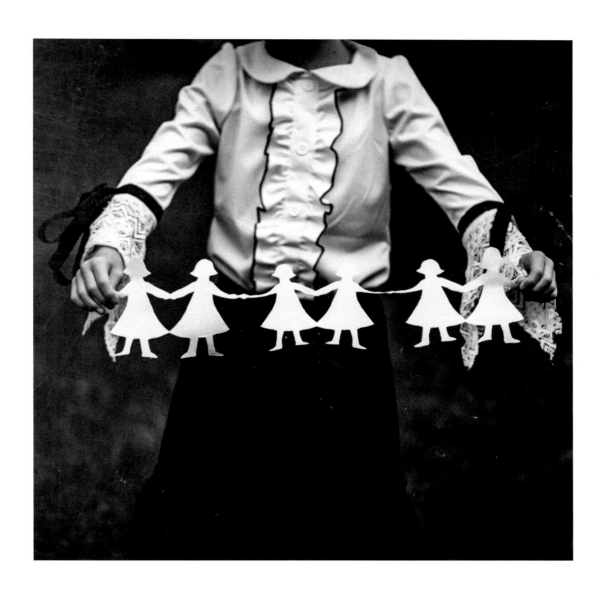

Women United, 2018

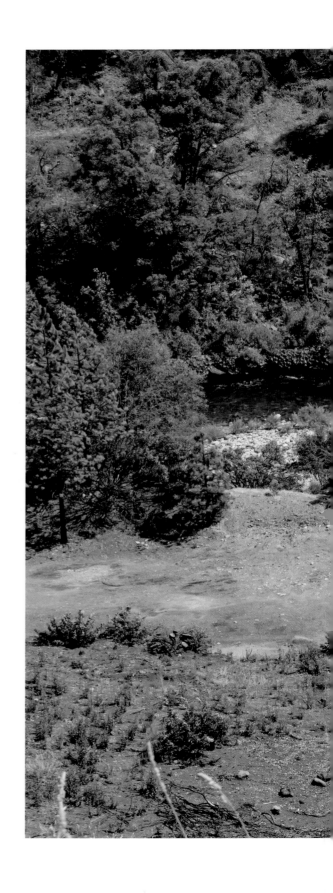

Around the Bend, Oregon, 2019

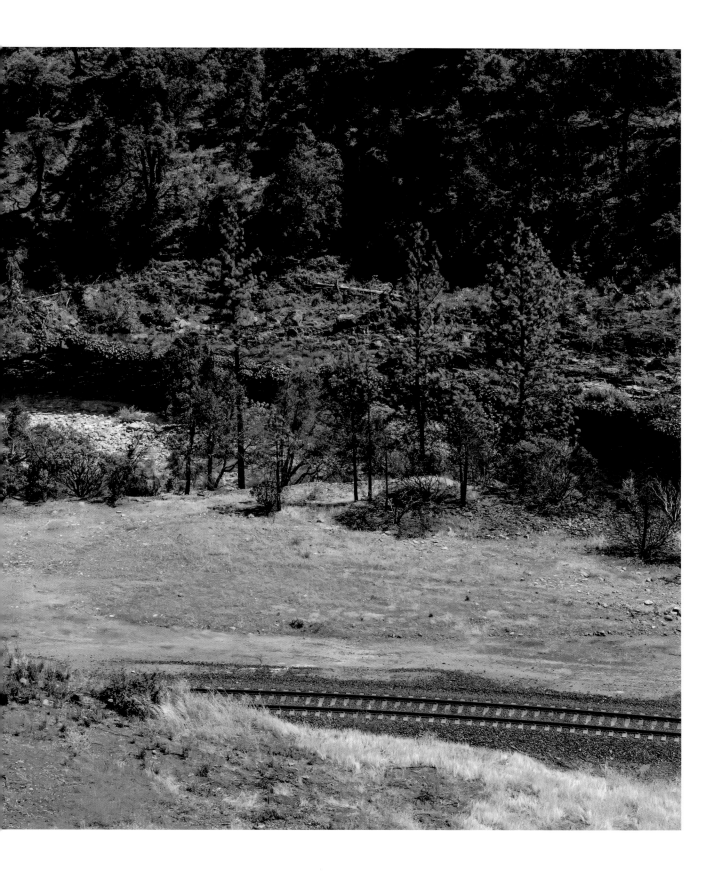

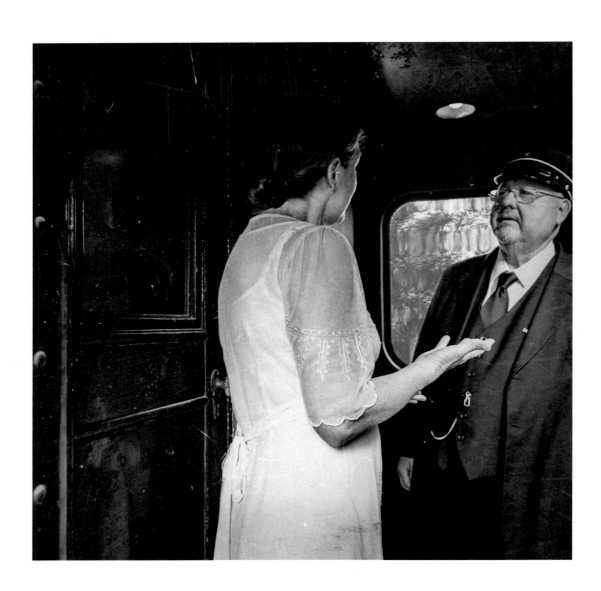

A Wonderful Argument, Oregon, 2019

"Just been having a wonderful argument with the conductor and pullman car conductor got them over to our side."

—Inez Milholland, letter to her husband, Eugen Boissevain, October 10, 1916

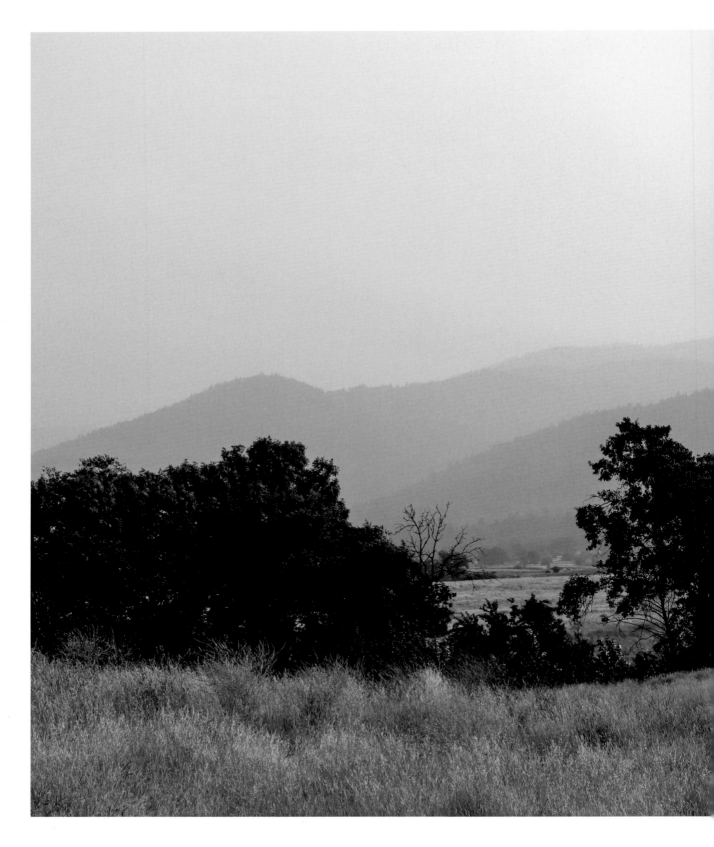

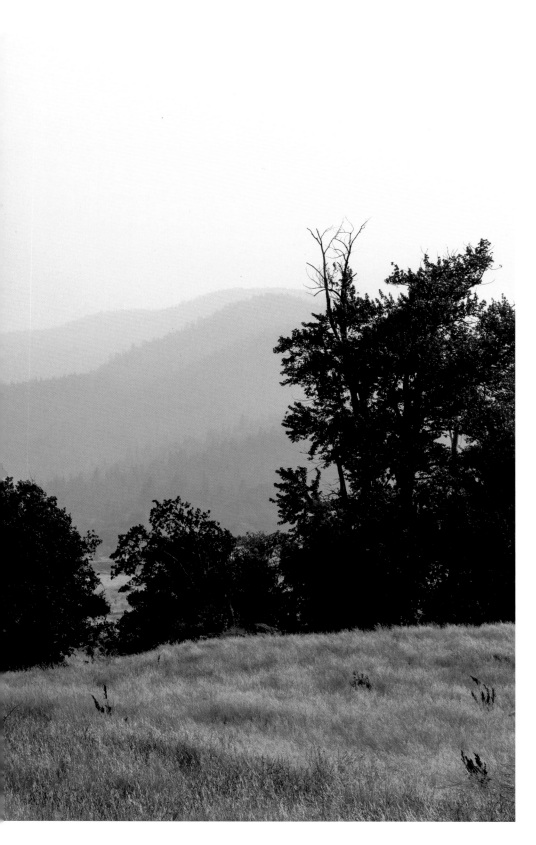

Mountains through the Haze,
Oregon, 2019

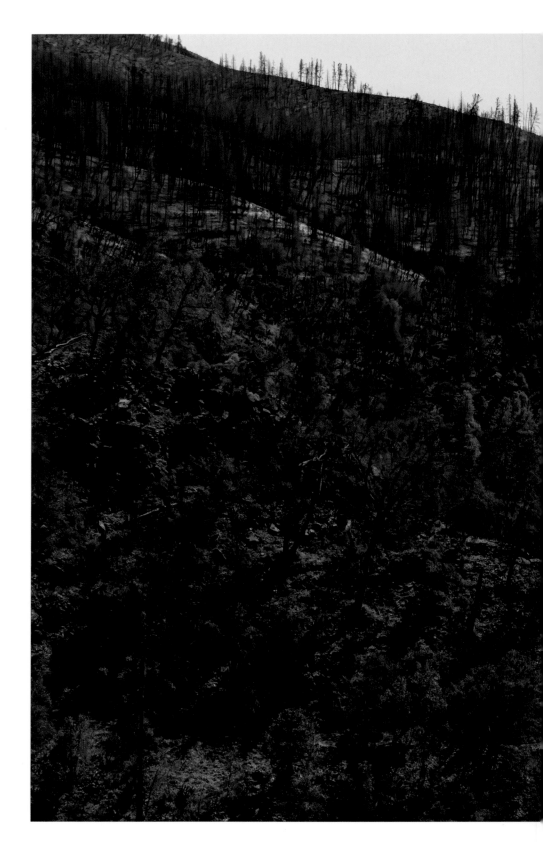

Charred Land, Oregon, 2019

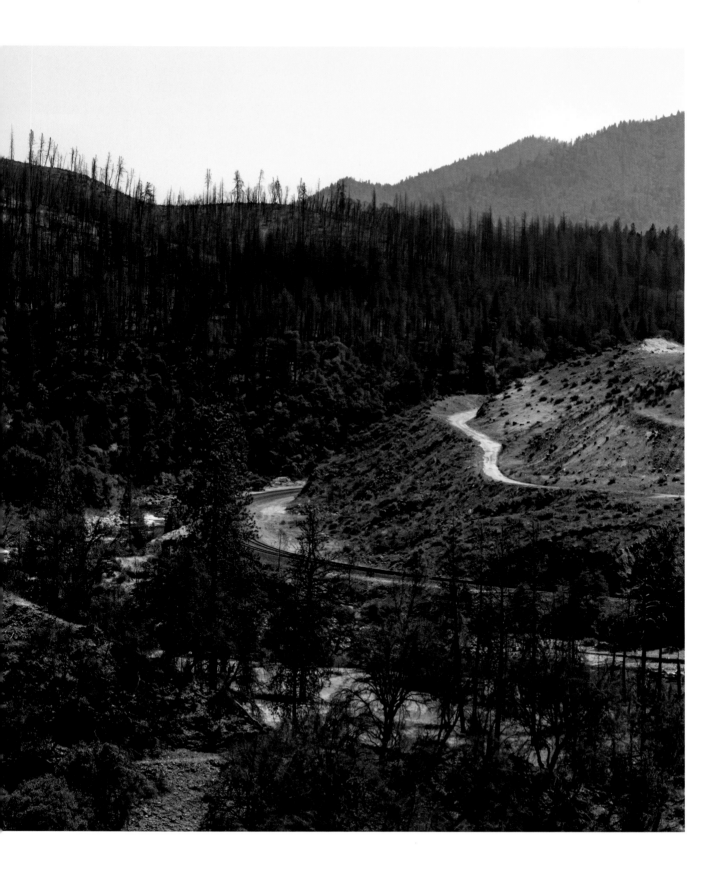

Inez Boissevain to Talk at The Dalles

Famous Suffrage Worker, Campaigning for Hughes and the Republicans, Will Speak to Women From Train.

The Dalles, Or., Oct. 10.—Inez Milholland Boissevain, famous suffragist, speaks here this afternoon from the train at 4 o'clock. Women of the Hughes club will greet her. She talks for Hughes and Republicanism.

Oregon Daily Journal, Portland, October 10, 1916

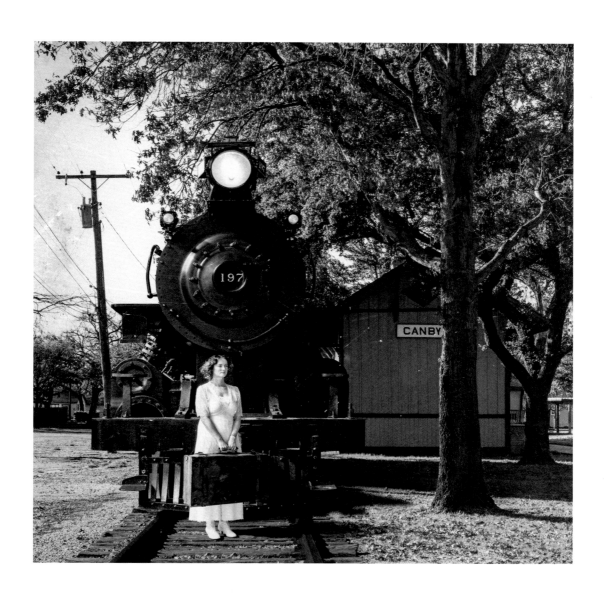

Bound for Medford, Oregon, 2020

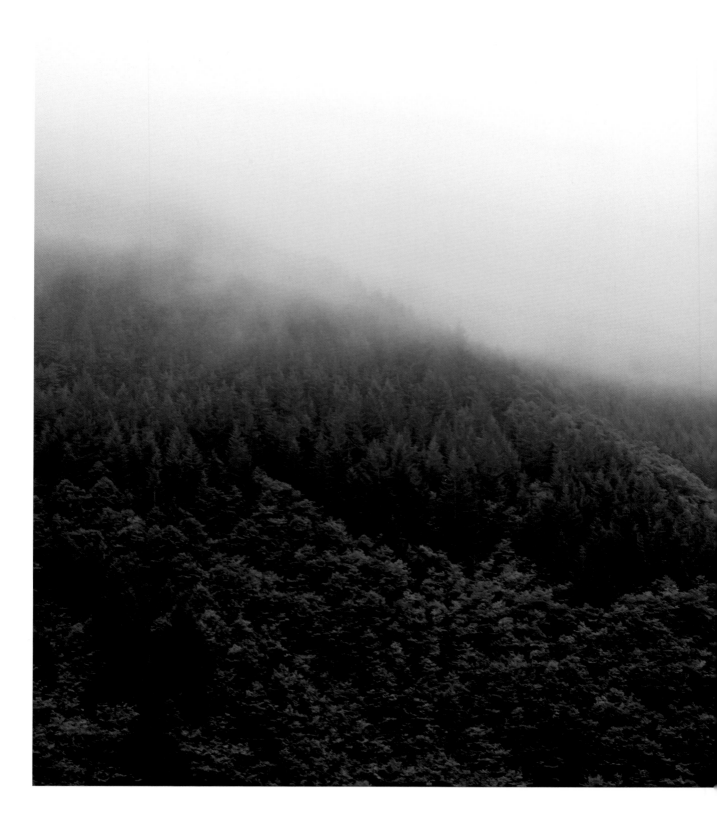

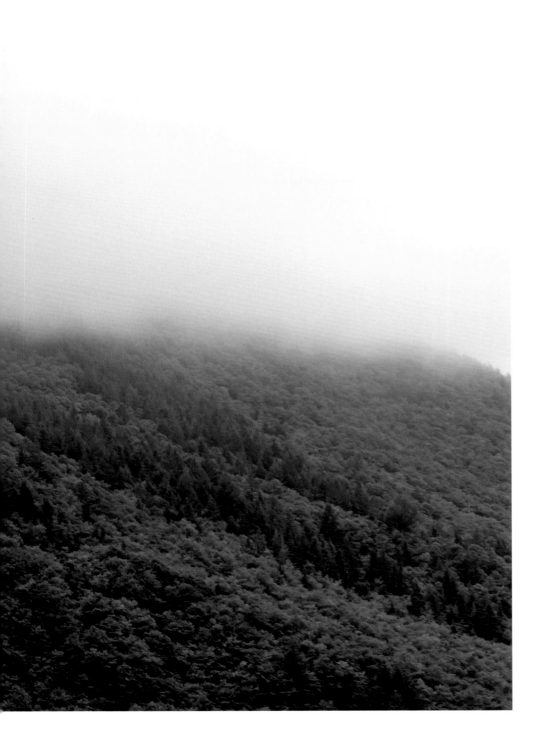

Mountain Pass in Fog,
Oregon, 2019

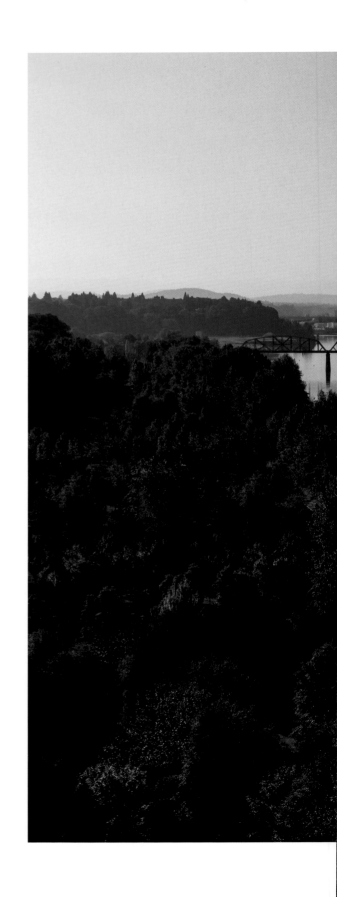

Approaching Portland, Oregon, 2019

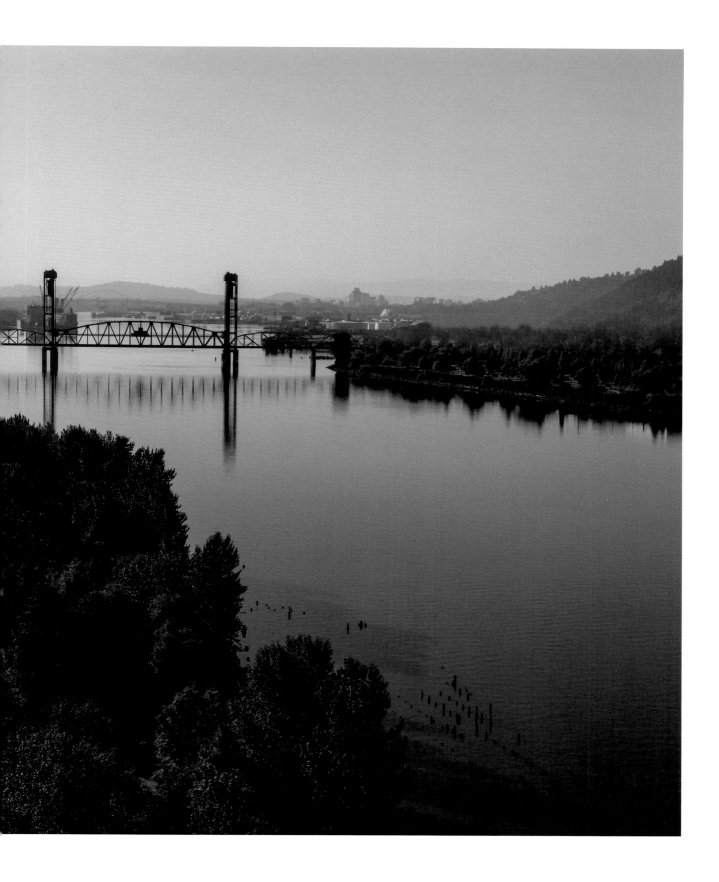

Mezzanine, Multnomah Hotel, Portland, Oregon, 2019

THE MULTNOMAH will establish and maintain its reputation as "Another of America's Exceptional Hotels." Residents of Portland and travelers from the world over will be welcomed after Tuesday, October 10th, 1916.

Opening the 1916 season on Tuesday night, the Gul Reazee Grotto Band will hold a Ball in the Grand Ballroom at 8 o'clock.

A Banquet in honor of Mrs. William Kent and Inez Mulholland will be given by the National Woman's Party in the Assembly Hall, with covers set for five hundred persons.

A special opening Dinner at $2.00 per cover will be served at 6:30 P. M. in the Arcadian Gardens. Reservations for tables should be made with Mr. Thompson, Superintendent of Service (Broadway 4080).

The Royal Purple and Imperial Russian Orchestras have been permanently engaged by the Multnomah Hotel. They will play daily in the hotel dining-rooms and Arcadian Gardens. HARRY E. STINSON,
Manager.

season includes a full symphony con- | room and hallway kalsominers and pa- | obscene letter was written to her by

Sunday Oregonian, Portland, October 8, 1916

Portland Union Station, Oregon, 2019

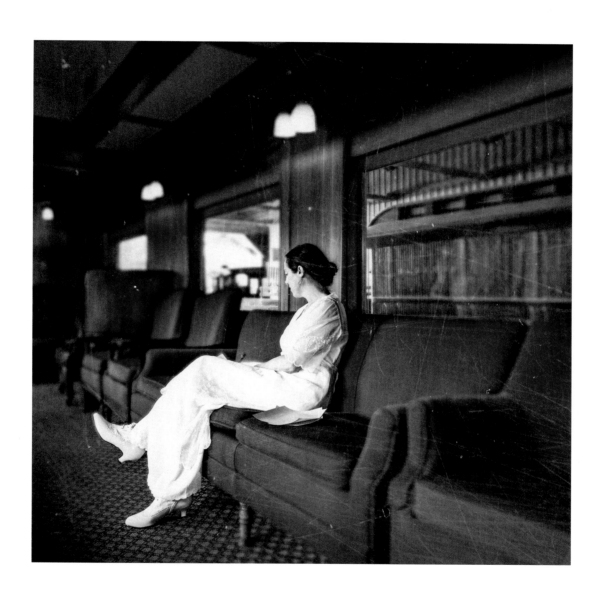

Writing a Speech, first-class car on the way to Seattle, Washington, 2018

"We come. We come at last.
Night's portal we have past.
We come. We come. Trust thou our might.
Thou, too, shall walk in Light."

—Lyrics from "Song of the Free Women," written by Sara Bard Field
and set to "La Marseillaise," 1915

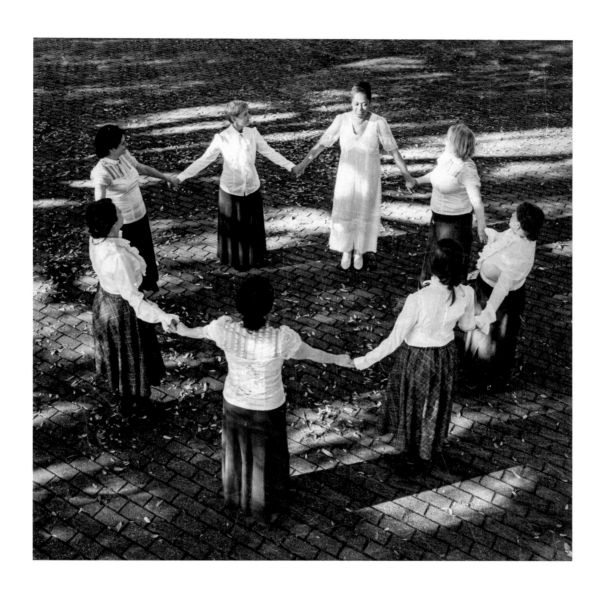

We Will Not Fall Down, 2019

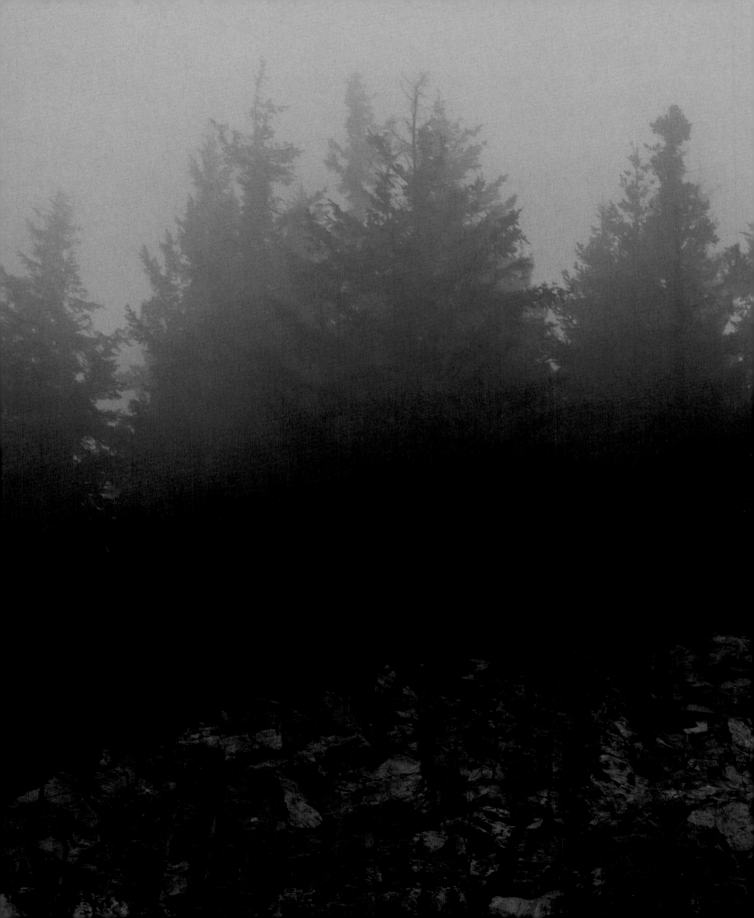

October 11–13, 1916

Portland, Oregon
to
Seattle *and* Spokane, Washington

"It is beautiful. The city is swathed in fog, so I don't know what it is like. But this blue is a gem."

—Inez Milholland, letter to her husband, Eugen Boissevain,
October 12, 1916

Nightscape, Seattle, Washington, 2019

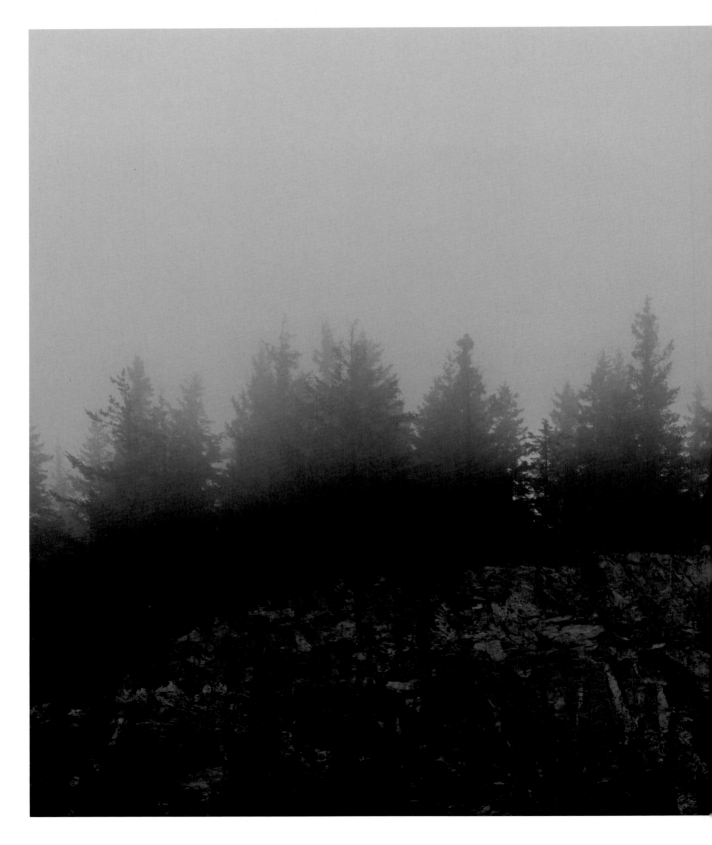

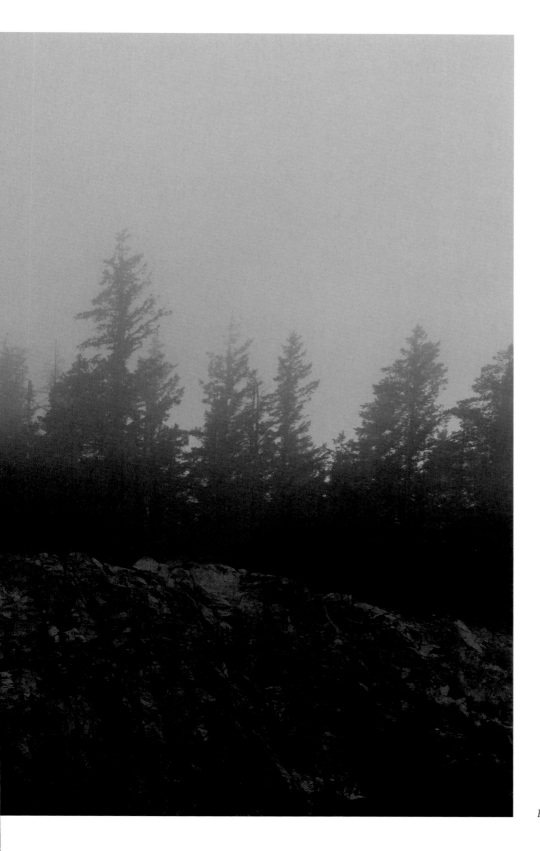

Blue Gem, Washington, 2019

Fogscape, approaching Tacoma, Washington, 2019

Fever, Aches, and Pains, 2018

"*I am taking a combination of arsenic and strychnine and iron and I think it helps me.*"

—Inez Milholland, letter to her husband, Eugen Boissevain, October 8, 1916

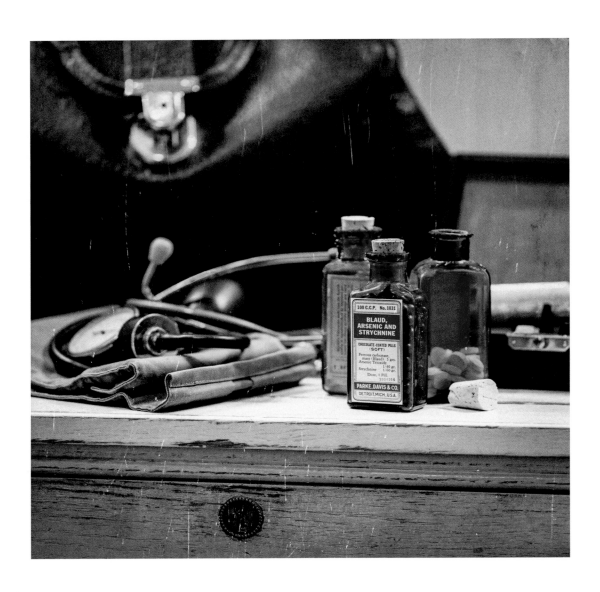

Arsenic and Strychnine, The Sunset Club, Seattle, Washington, 2018

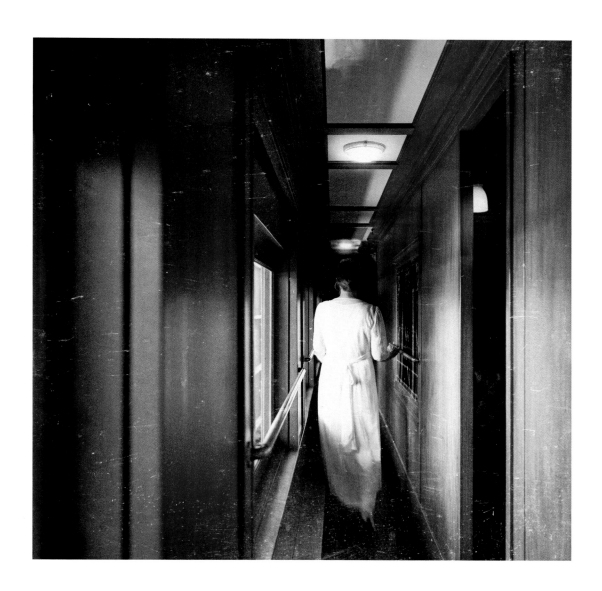

Marching Onward, Washington, 2018

Beautiful Inez Agin Wilson But Not Very Ardent For Hughes

A large audience filled the parlor of the Tacoma hotel Thursday afternoon to hear Mrs. Inez Milholland Boissevain, famous suffragist and beauty, set forth the aims and principles of the Woman's Party.

Mrs. Boissevain is a handsome woman, and an able speaker.

Noticeable in the audience were many democratic women and a number of suffrage leaders who had protested against the methods of the Woman's Party, and what they declared to be the unauthorized use of their names by the local branch, but the speaker was listened to with attention and there was no "heckling."

Lukewarm on Hughes.

Her talk was about equally divided between arguments for suffrage, and for the federal amendment, and threats against the democratic party and President Wilson.

She repudiated connection with the Hughes special which is due in Tacoma Friday evening, and declared the Woman's Party is not supporting Hughes especially. "It matters little to us who is elected, providing the democrats are defeated by the women in the suffrage states," she said.

"I would vote the socialist ticket myself, if I could vote," she added.

Blames Southerners.

She took several falls out of the southerners, whom she called the most reactionary element in the United States. She asserted that congress and the president are dominated by southern democrats, and that this is responsible for the party's failure to declare for the federal amendment.

"Women are kept in subjection," she affirmed, "by that portion of the republic which believed in and tried to perpetuate the institution of slavery."

Her arguments for suffrage roused sympathetic applause several times.

Tacoma Times, Washington, October 13, 1916

MRS. BOISSEVAIN TOO ILL TO SEE PARENTS

LOS ANGELES, Nov. 13.—Rushed across the continent as fast as trains could move, Mr. and Mrs. John E. Milholland of New York, parents of Mrs. Inezz Milholland Boissevain, suffrage leader, who is critically ill here, were halted at the door of their daughter's sick room in the Good Samaritan hospital today owing to Mrs. Boissevain's weakened condition.

Surgeons told Mr. and Mrs. Milholland the sight of them might cause a fatal relapse for their noted daughter.

Surgeons reported her condition slightly improved today, adding that there is hope of her recovery.

Tacoma Times, Washington, November 13, 1916

The Star of Hope, 2019

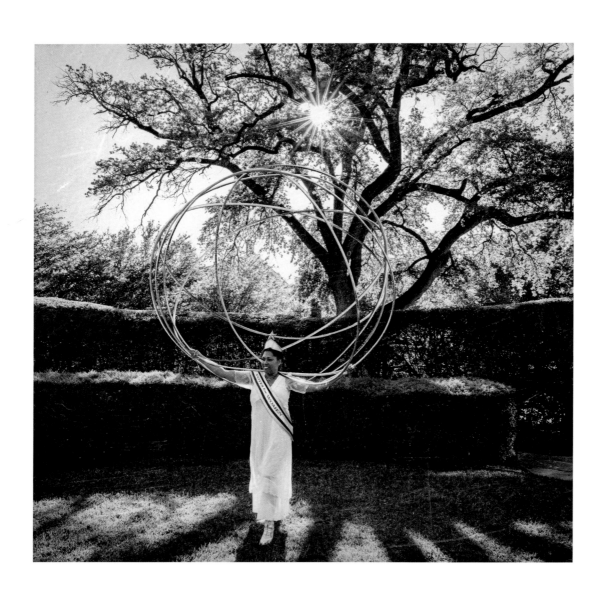

Women Hold Up Half of the Sky, 2019

"As you act in the next months, so the fate of women will be determined in the coming year. You must say to the rulers of the nations 'You can not proceed without us.'"

—Inez Milholland at the Strand Theater, Spokane, quoted in the *Spokesman-Review*, October 14, 1916

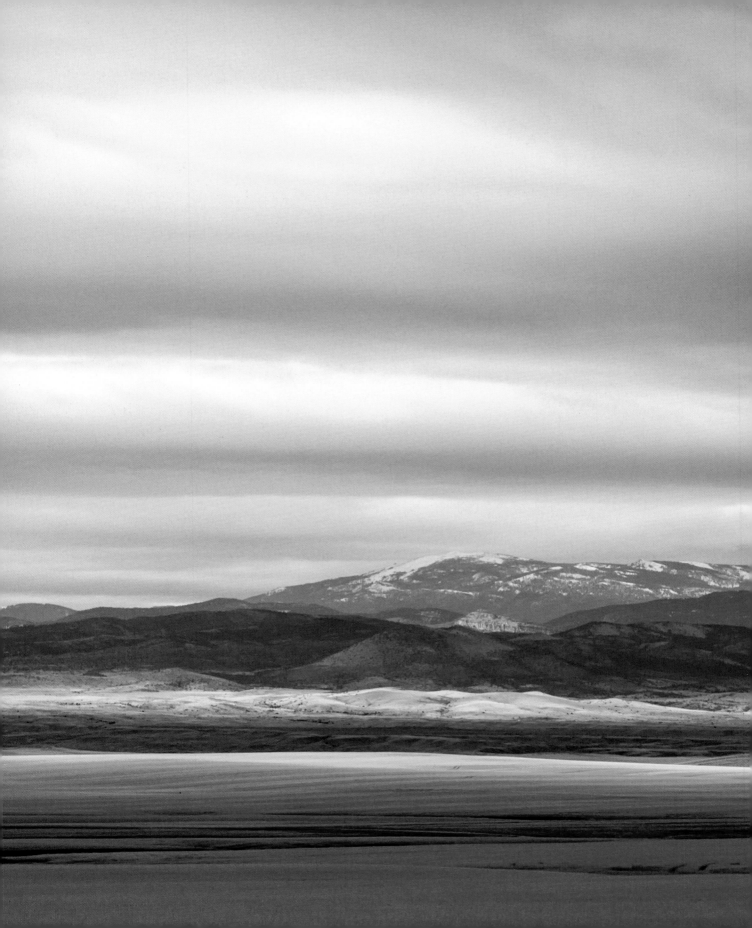

October 13–14, 1916

Spokane, Washington
to
Great Falls, Montana

Dusting of Snow, Montana, 2019

Special Flying Envoys, Montana, 2019

BANK PIONE

CUT BANK, TETON COUNTY, MONTANA, FRIDAY, OCTOBER 13, 19

Noted Suffragist to Speak Tomorrow

Mrs. Inez Millholland Boissevain, noted lawyer, orator and suffrage leader, declared the "most beautiful woman in America," will arrive here tomorrow at one o'clock and will deliver an address from the train platform. The famous lecturer will have a special message to the women of Cut Bank.

Hear this brilliant woman at the Railway station tomorrow

Parent-Teacher Meeting

Thursday was "Mothers' Day" in the kindergarten of the local

Getting Stale

During the past year this section of Montana has been del

Cut Bank Pioneer Press, Montana, October 13, 1916

INEZ MILHOLLAND BOISSEVAIN

:: *PALACE THEATER* ::

TONIGHT

8:30 O'clock.

Bringing the last appeal of the eastern women to the West in behalf of the

NATIONAL WOMAN SUFFRAGE. EVERYBODY COME

Black Eagle Band

Adv. paid for by C. L. Rowe.

Great Falls Daily Tribune, Montana, October 14, 1916

"*I found a great crowd at the station. I couldn't think why until I heard someone say 'there she is.' Then I suspected (my heart sank, I don't mind telling you) then the brakeman and porter said 'They are looking for you' so I went to the back of the train and made a speech—fairly good.*"

—Inez Milholland, letter to her husband, Eugen Boissevain, October 9, 1916

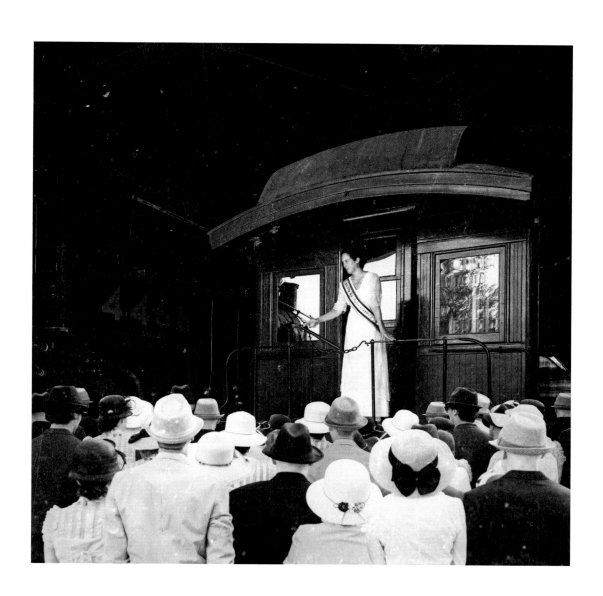

Whistlestop Speech, Cut Bank, Montana, 2018

Amber Waves of Grain,
Montana, 2019

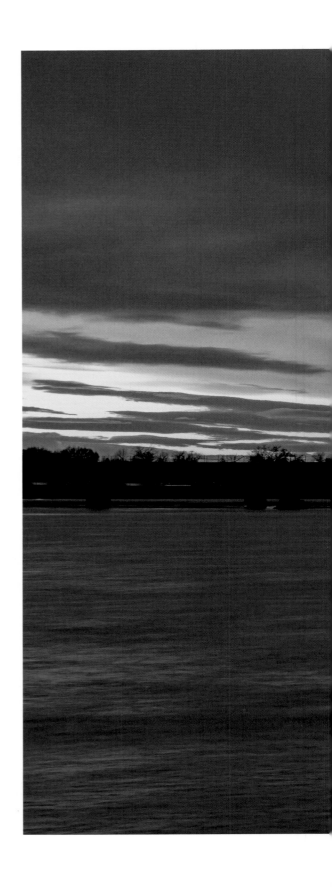

Crossing the Missouri River, Great Falls, Montana, 2019

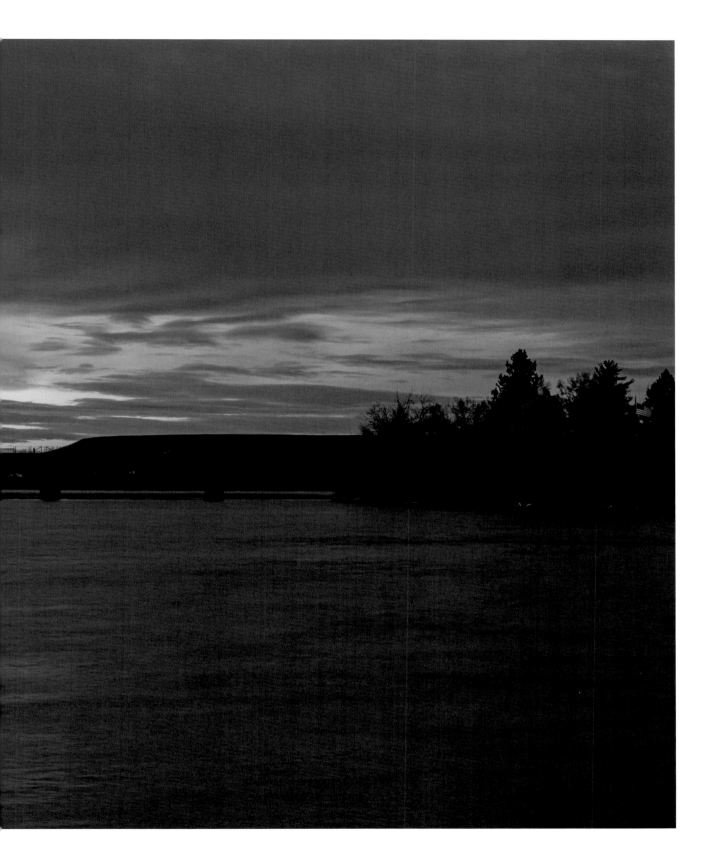

Helping Hands, 2018

"If women use their power now in standing together the fight is over, the victory is won for women."

—Inez Milholland, quoted in *The Suffragist*, October 14, 1916

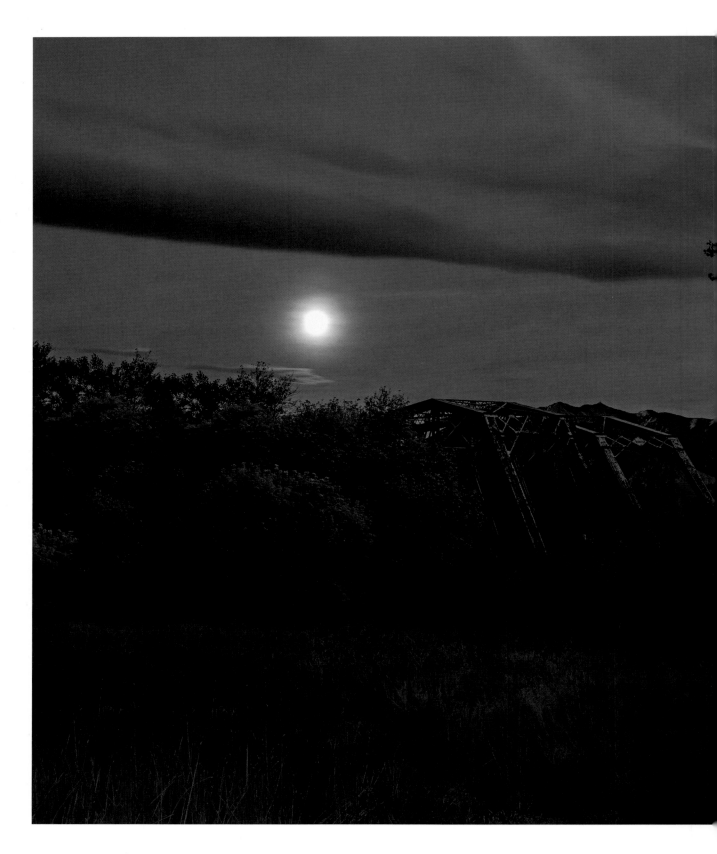

Railroad Trestle Bridge, Montana, 2018

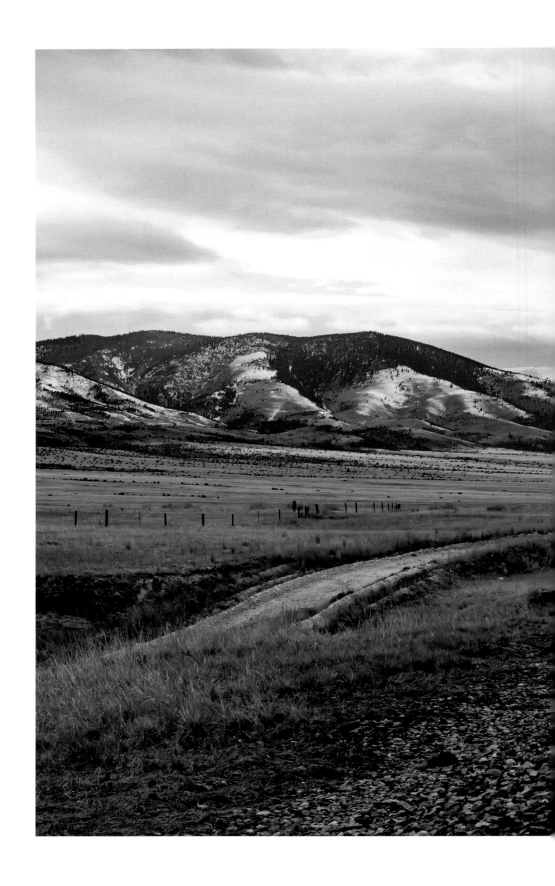

Leaving Helena,
Montana, 2019

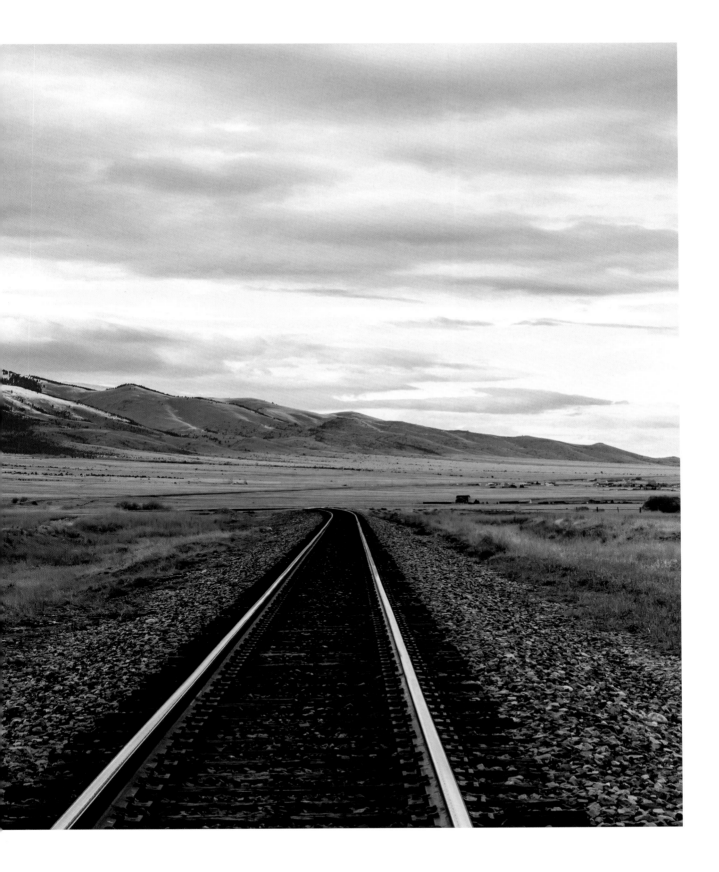

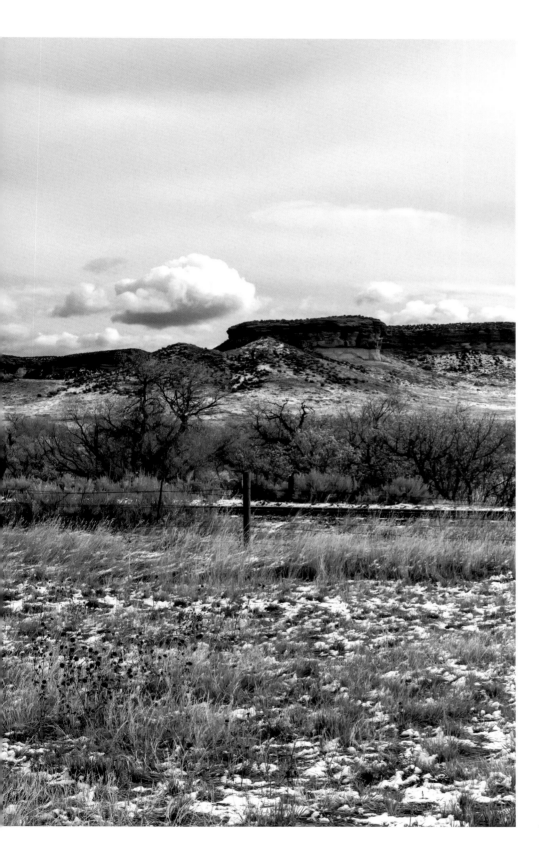

Heading to Utah, Montana, 2019

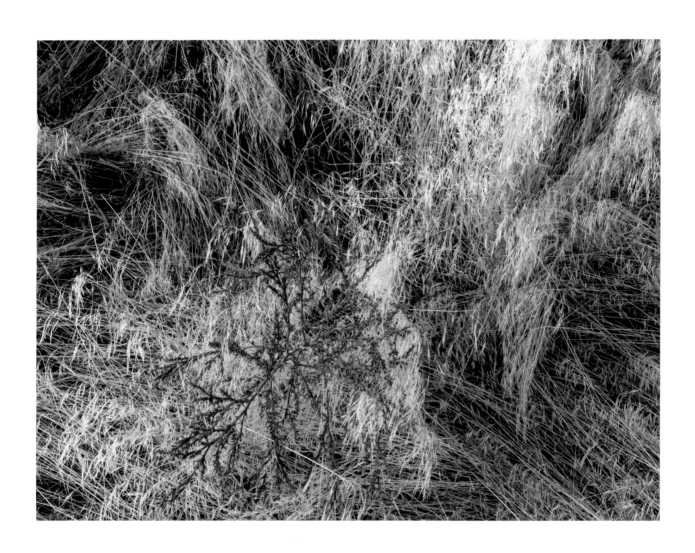

Finding Beauty in the Small Things, Montana, 2019

THE BEAUTY OF THE SUFFRAGE WORKERS

—Copyright by Underwood & Underwood, New York.
MRS. INEZ MILHOLLAND BOISSEVAIN.

FAMOUS SUFFRAGIST ARRIVES IN BUTTE

Mrs. Inez Milholland Boissevain Will Spend Today in This City.

Mrs. Inez Milholland Boissevain and Mrs. Abbey Scott Baker arrived in Butte last night at 9:20 o'clock from Helena and were met by a number of prominent Butte women, including Mrs. C. P. Irish, Mrs. James Casey, Mrs. T. A. Grigg, Mrs. J. C. Pyle, Mrs. Robert Jennings, Miss Mary O'Neill and others, and escorted to the Thornton hotel.

The fame of Mrs. Boissevain as the handsomest suffragist in America had aroused quite a good deal of curiosity among the many Butte people who had never seen her and her appearance was in no way a disappointment. Tall and stately, with an aristocratic bearing that told of a heritage of good lineage, with a handsome face, sparkling eyes and, above all, a most winning smile. With all her beauty she combines a strong personality.

Mrs. Boissevain is not yet 30 years of age. From the days when she was in Vassar she has been battling for women and the rights of women. She was educated for the law and admitted to the bar, but when she married Mr. Boissevain, a Hollander, she lost the right to practice as an American

attorney and now she is unwilling to regain that right through her husband taking out naturalization papers. She declares she will fight until the law is changed and she can secure the right to practice without regard to her husband's allegiance.

Mrs. Boissevain is just now interested in a famous murder case in New York in which she acted as legal adviser in a great measure for an Italian who was convicted of murder. His name is Stielo, and she is certain in her own mind that the man is innocent, although he has been convicted and was at one time about to be electrocuted when she succeeded in securing a reprieve for him at the last moment.

Mrs. Boissevain and Mrs. Baker will remain in Butte today. This morning they will make a trip through one of the mines and at 12:30 will go to the Silver Bow club, where the luncheon in honor of Mrs. Boissevain will be given.

Mrs. T. A. Grigg will preside as toastmistress and Mrs. C. S. Haire of Helena, who is the state president of the woman's party, will make an address of welcome.

This afternoon at 5 o'clock Mrs. Boissevain and Mrs. Baker will leave for Salt Lake City.

TEN KILLED IN

Anaconda Standard, Montana,
October 16, 1916

"I still am horribly bloodless, but I am trying to take care of myself and resting a lot."

—Inez Milholland, letter to her husband, Eugen Boissevain, October 8, 1916

Resting, 2018

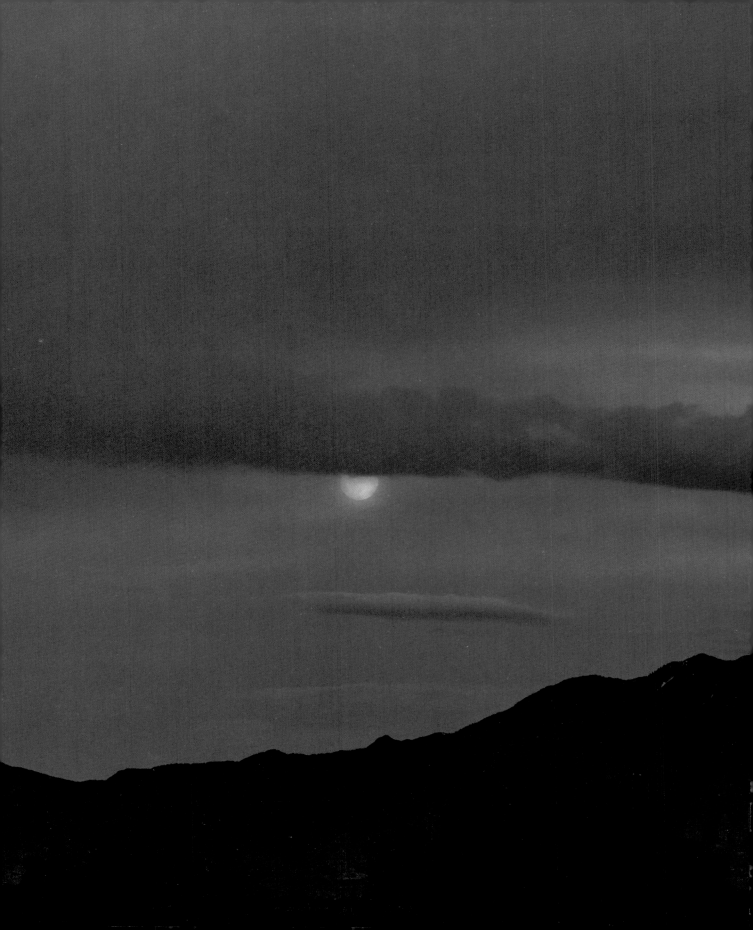

October 15–17, 1916

Great Falls, Montana
to
Salt Lake City *and* Ogden, Utah

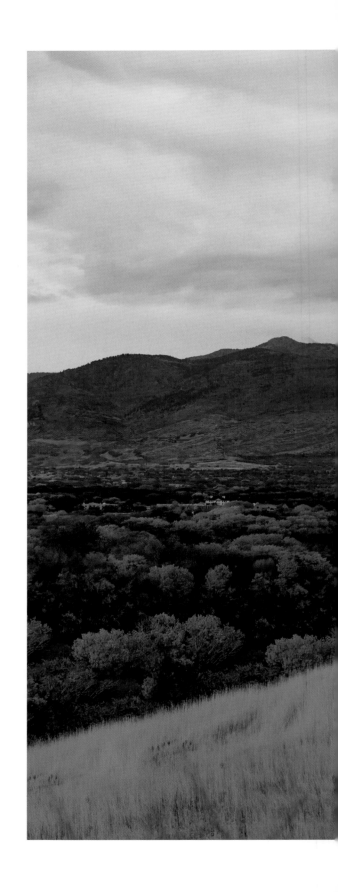

A Storm is Building, Ogden, Utah, 2018

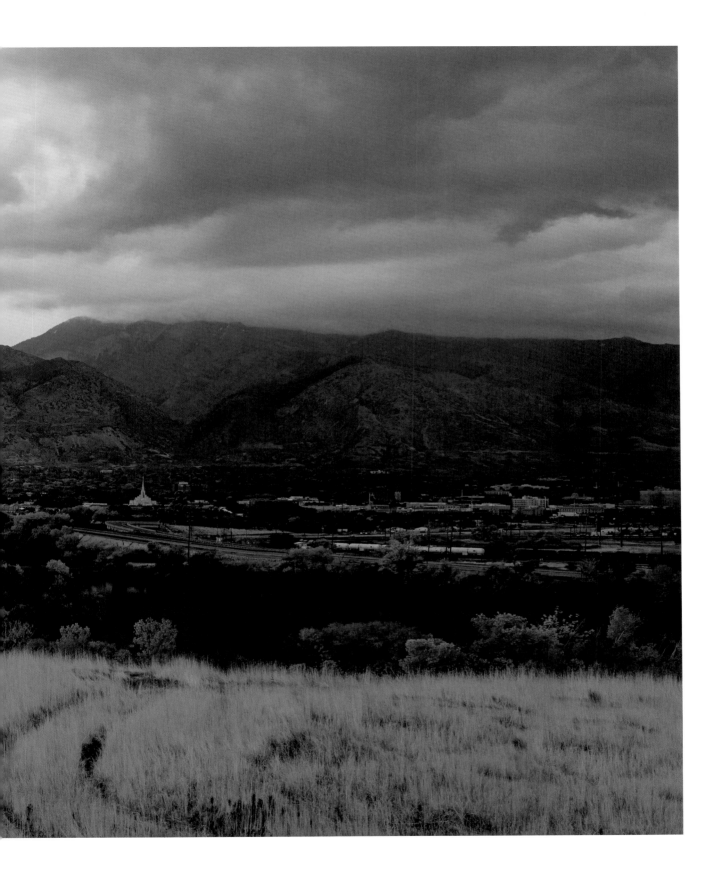

Practicing a Speech, Reed Hotel, Ogden, Utah, 2018

'MAKE CHOICE,' WOMEN PLEAD

Mrs. Boissevain and Miss Todd Tell Friends of Suffrage Action Needed.

WILSON IS CRITICIZED

Declared Not Interested in Suffrage Cause, Despite His Words.

Declaring that the "women of the eastern states want the help of the women of the west," Mrs. Inez Milholland Boissevain and Miss Helen Todd last night addressed one of the most enthusiastic and largest political meetings ever held in this city to listen to women speakers. More than 1500 people turned out at the Salt Lake theatre to hear the purposes of the National Women's party discussed. It was the "last appeal" of the women of the east who desire a federal constitutional amendment.

The Democratic party was taken to task for its failure to give its influence and support to the resolution which was introduced in the Senate by Senator George Sutherland submitting to the states for ratification an amendment providing for universal suffrage.

President Wilson was criticized for his efforts to keep the resolution from coming to a vote in the Senate. Miss Helen Todd said that the "Jim Nugent machine" of New Jersey had defeated women's suffrage in that state and intimated that President Wilson probably knew more about the "Jim Nugent machine" than he gave to the public. She asserted that the people of the country would never be aroused to the conditions of the women and children in the manufacturing districts of the east until the women and the men of the west gave their support to candidates who favored universal suffrage.

"President Wilson has made more speeches and written more words concerning freedom and equality of all citizens than any man who has ever been in the public eye and yet his words are words, and not deeds," said Miss Todd. "He has had the temerity to say that he wants woman's suffrage and yet he has never lifted his little finger to aid it. His words are charming to the ear, but his deeds will be passed upon at the coming election."

Mrs. Boissevain urged that the Wilson administration and President Wilson be defeated. She said in part:

Mrs. Boissevain's Speech.

"Our self

Herald-Republican, Salt Lake City, October 18, 1916

BRILLIANT WOMEN SPEAK

Inez Milholland Boissevain, the brilliant and beautiful, and Helen Todd, a forceful speaker who has a way of winning her audiences in no time, appeared before a more or less distinguished gathering of fifteen hundred people at the Salt Lake theatre on Tuesday night, to make a plea for a federal constitutional amendment, and during the course of the proceedings the Democratic party came in for a severe rebuke for its failure to support Senator Sutherland's resolution submitting an amendment providing for universal suffrage. The coming of Mrs. Boissevain and Miss Todd was in line with the policy of those mostly interested in bringing leading speakers on the subject here during their tour of the country, Miss Maud Younger who was here a fortnight ago, being another who is making a great effort to advance their cause. Mrs. Margaret Zane Cherdron presided at the meeting held at the theatre, and seated on the stage were a large number of ladies prominent in the local work. The speakers were greeted by an attentive and enthusiastic audience, which expressed its appreciation of the arguments of both speakers throughout the meeting. Both of them are internationally famous, an the local ladies who represent the party for which the speakers are sponsors, feel that this city was signally honored by their presence.

Goodwin's Weekly, Salt Lake City, October 21, 1916

"I can't wait to get to Salt Lake City for I expect to find there a letter and a telegram from you."

—Inez Milholland, letter to her husband, Eugen Boissevain, October 17, 1916

Telegram from Eugen, Salt Lake Union Pacific Railroad Station, Utah, 2018

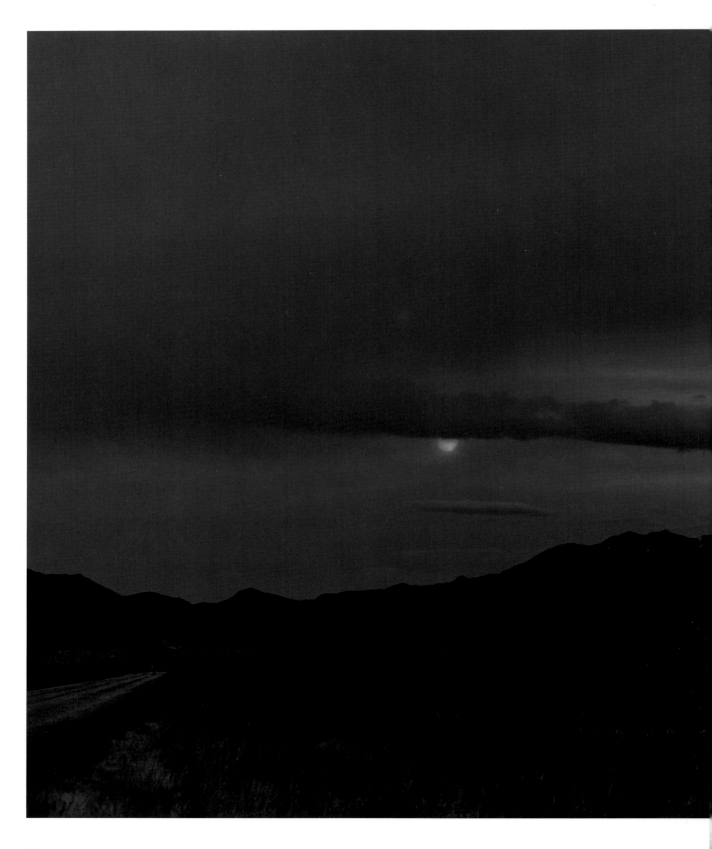

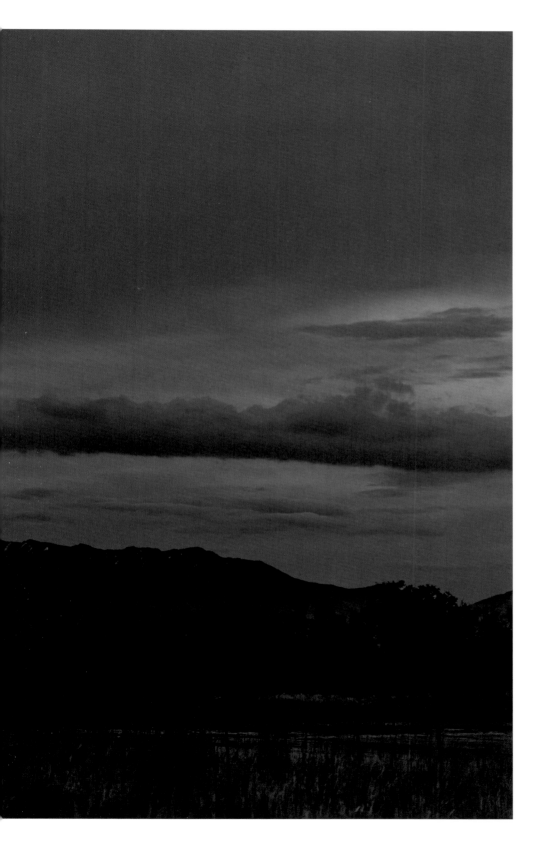

Nightfall, Utah, 2018

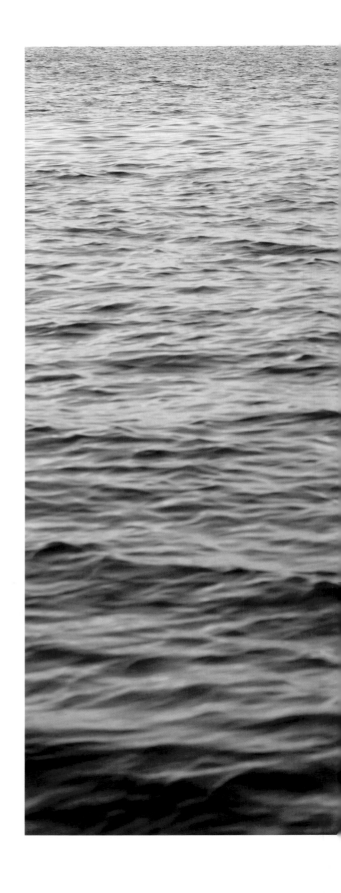

The Great Salt Lake, Utah, 2018

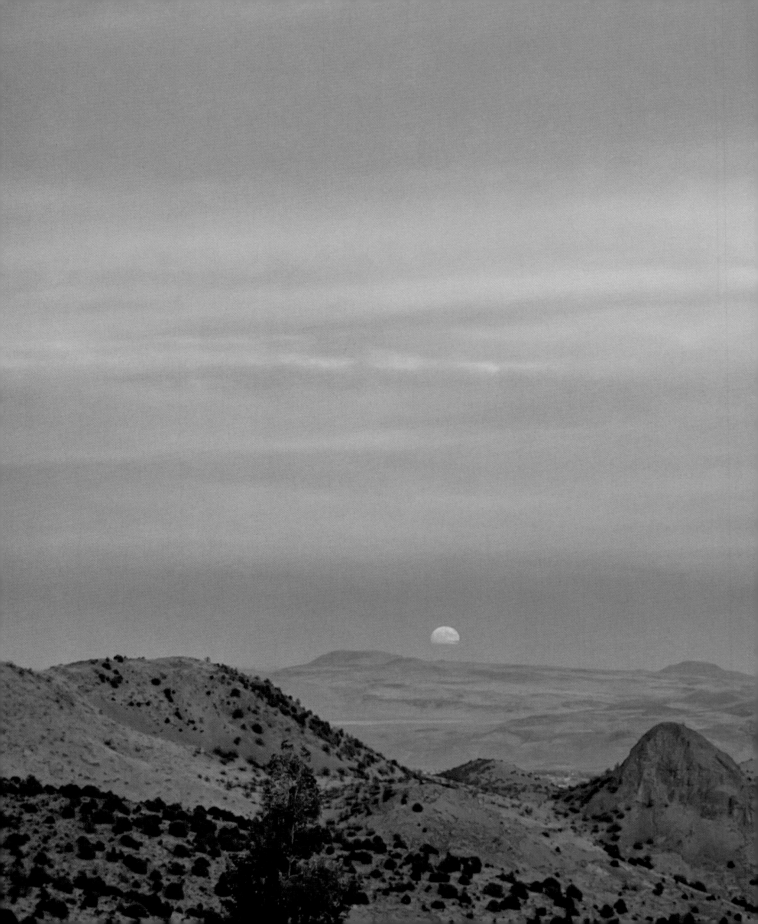

October 18–20, 1916

Ogden, Utah
to
Reno, Nevada

"*I am going to appeal to women to make the highest possible use of their ballots in helping to enfranchise half the people of a nation. Western women can do this and I believe they will.*"

—Inez Milholland, quoted in the *Reno Evening Gazette*, October 4, 1916

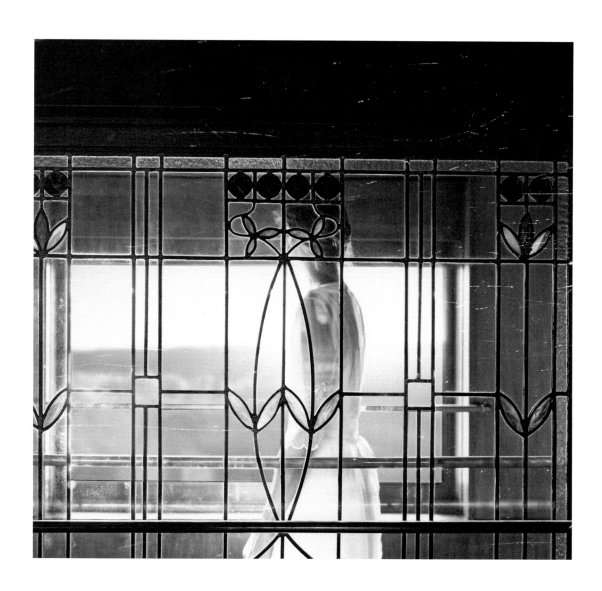

Drawing Near the Station, Winnemucca, Nevada, 2018

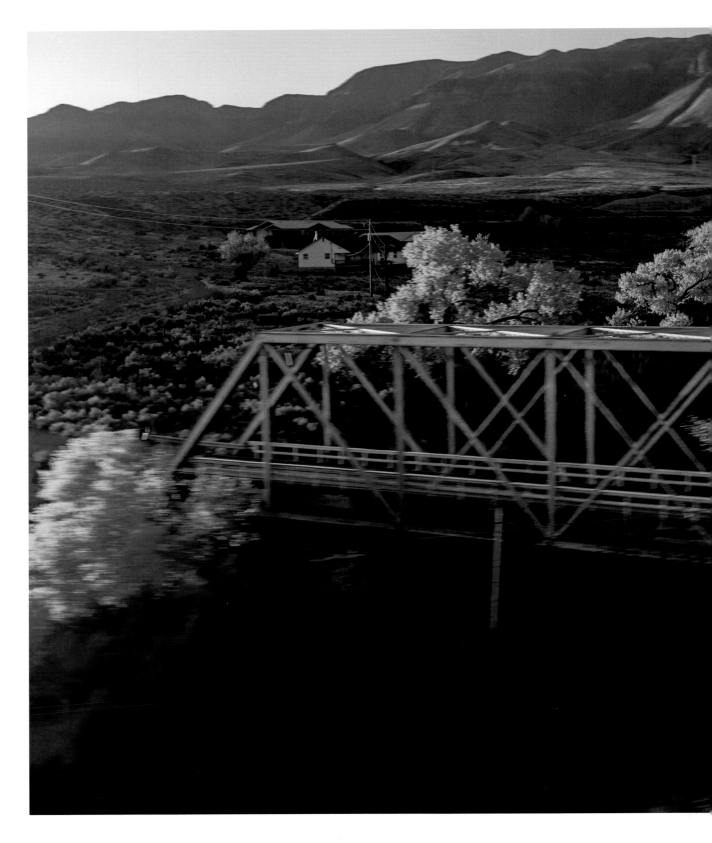

Dawn, Nevada, 2018

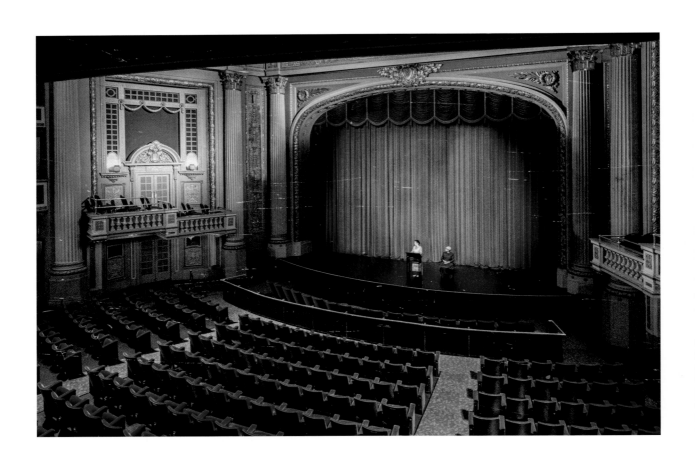

Majestic Theater, Reno, Nevada, 2019

FAMOUS SUFFRAGE BEAUTY HERE FRIDAY

Mrs. Inez Boissevain to Talk At Mass Meeting at Majestic Theater Against Wilson

MRS. INEZ MILHOLLAND BOISSE-VAIN

Mrs. Inez Milholland Boissevain of New York, known for her eloquence and her beauty all over the country, will be the principal speaker at a mass meeting of the Woman's party in the Majestic Friday night. Miss Anne Martin, national chairman of the Woman's party, who is now making a speaking trip through the state, will return to Reno to preside at the meeting.

Mrs. Boissevain is making a whirl-wind tour through the 12 suffrage states to bring to women the final appeal from Eastern women for help in their fight for enfranchisement. This appeal asks women to withhold support in order that proof may be given to all political parties that women will not support any party which opposes national woman suffrage as the Democrats have done in the last congress.

Mrs. Boissevain has been prominent in suffrage ever since her student days at Vassar, when she enrolled two-thirds of the girls in a suffrage society. She was the most striking figure in the famous suffrage parade in Washington the day before President Wilson was inaugurated, when she rode on a pure white horse as a herald at the head of the procession.

Mrs. Boissevain is such an ardent advocate of international peace that she was induced to join the Ford peace expedition, but she is now campaigning against the president who asserts he has "kept us out of war," because she says that the enfranchisement of the women of the nation is a greater safeguard against war than the power of any one individual, even the president of the United States. She declares that so long as the president is opposed to national woman suffrage she is opposed to him.

Her first meeting in Nevada will be held at Winnemucca tomorrow night. Mrs. Boissevain is accompanied on her tour by Mrs. Abby Scott Baker, a prominent figure in social and navy circles in Washington. Mrs. Baker is the national press chairman of the Woman's party.

RENOGRAMS

Reno Evening Gazette, October 17, 1916

Suffrage Mountains,
Nevada, 2018

BEAUTY OF SUFFRAGE RANKS COMING HERE

Extensive Preparations for Coming to Reno of Inez Milholland Boissevain

Extensive preparations are being made for the coming of Inez Milholland, who will be in Reno next Friday to speak for the National woman's party.

On Friday afternoon a reception for Mrs. Boissevain, who is known as the most beautiful woman in the suffrage movement, will be given at the home

ELKO MILL SOON TO RESUME OPERATIONS

The Lowell Milling company, it was learned yesterday, is about to take over and reopen the flour mill in Elko, owned by W. T. Smith and which has been shut down for several years. A growing increase of flour is responsible for the reopening of the mill. J. D. Percival will be in charge as manager.

of Mrs. George Taylor, 233 S. Virginia street. Friday night a mass meeting will be held at the Majestic theater.

Miss Anne Martin, who is now making a speaking trip through the state, will meet Mrs. Boissevain at Winnemucca, where a meeting will be held Wednesday night and come with her to Reno to preside at the mass meeting here.

Nevada State Journal, Reno, October 15, 1916

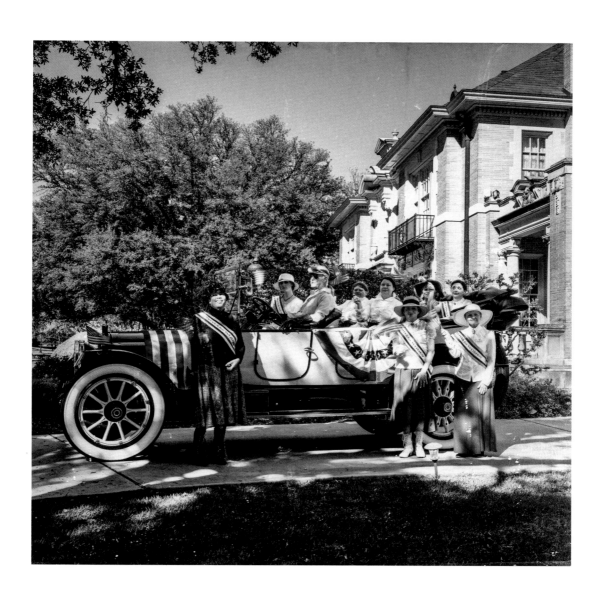

Automobile Caravan from the Train Station, Reno, Nevada, 2019

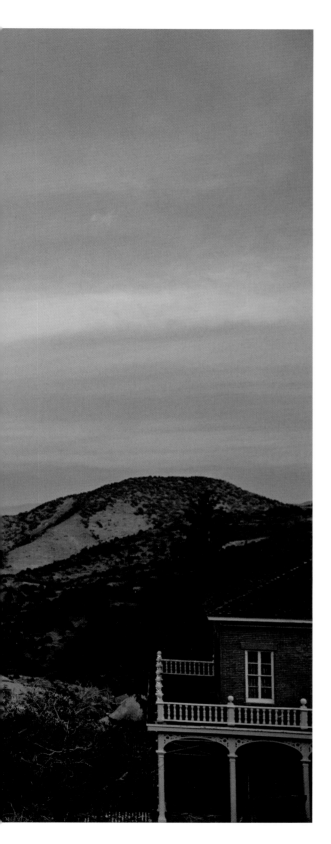

Moonrise, Virginia City, Nevada, 2018

Motoring to Meetings, Nevada, 2018

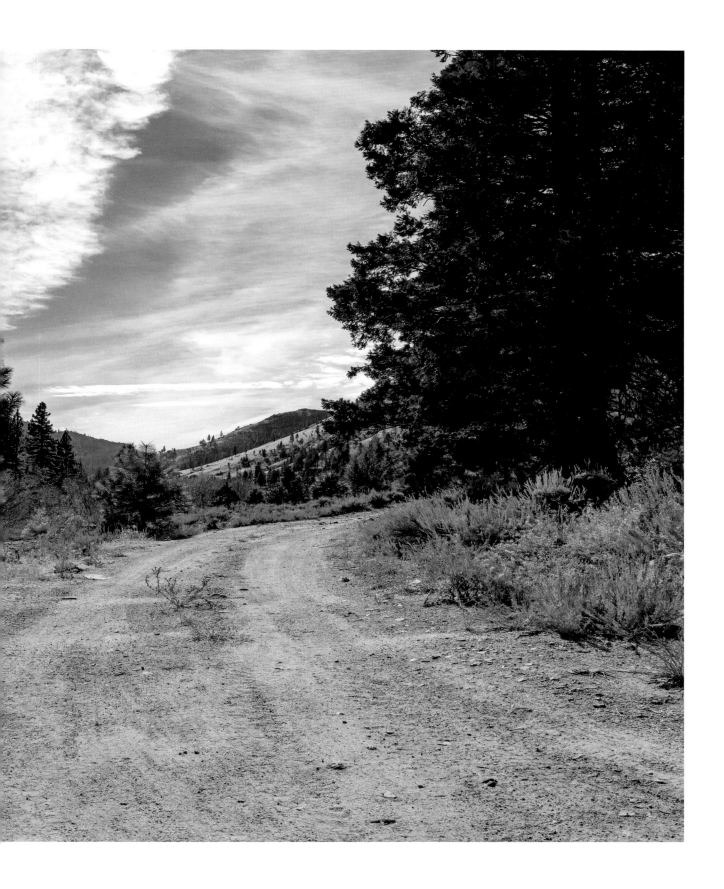

Back Down the Mountain at 1 a.m., outside of Carson City, Nevada, 2018

*"Then we leave for Sacramento
and all the time I am saying
'one day nearer my beloved.'"*

—Inez Milholland, letter to her husband, Eugen Boissevain,
October 20, 1916

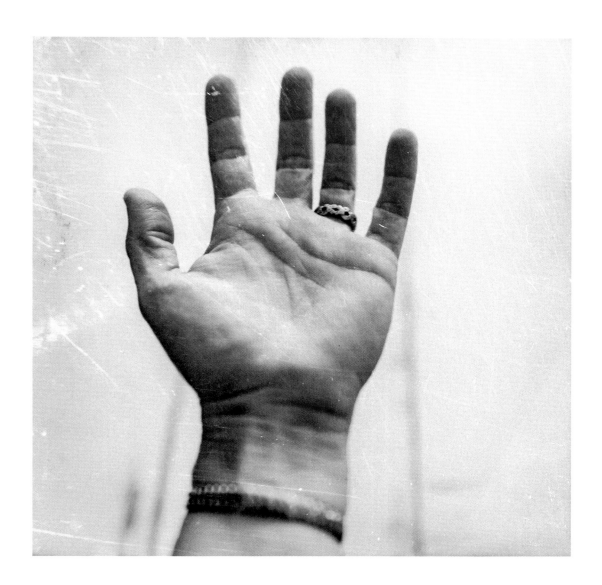

Life Line, 2019

October 20–24, 1916

Reno, Nevada
to
San Francisco *and* Los Angeles, California

"If you stand together and pile up a protest vote, victory is ours—the long fight of sixty years is over."

—Inez Milholland at the Palace Hotel, San Francisco, quoted in the *Oakland Tribune*, October 22, 1916

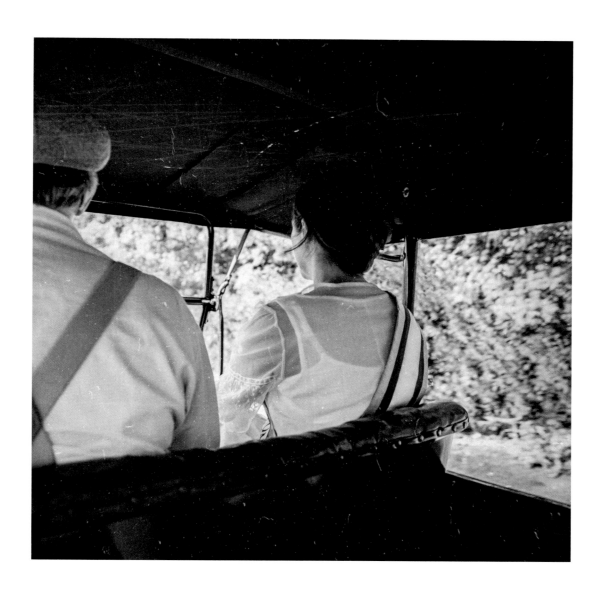

On the Road, California, 2018

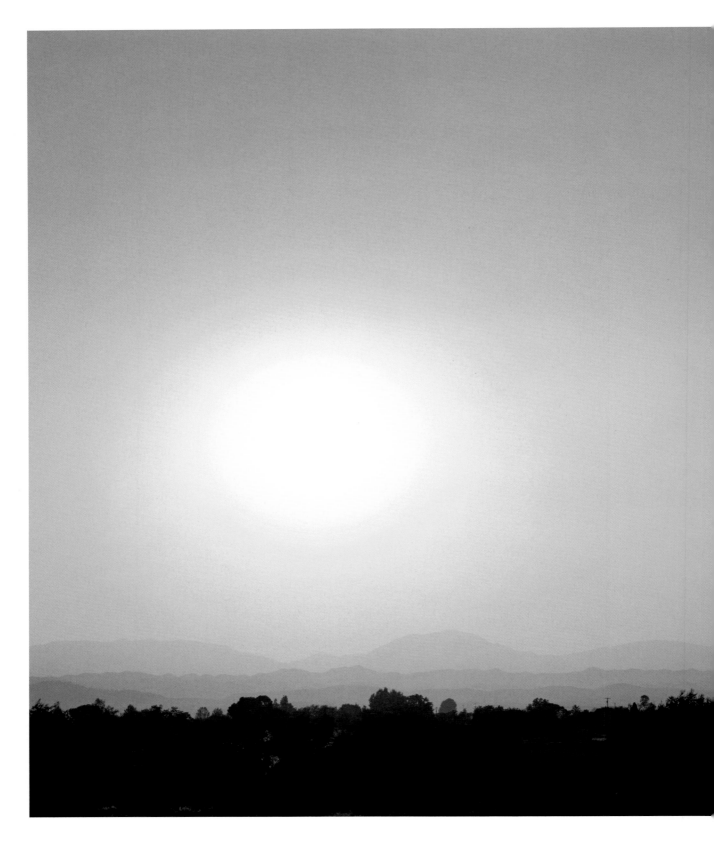

Sunset, California, 2019

A Breath of Fresh Air, California, 2019

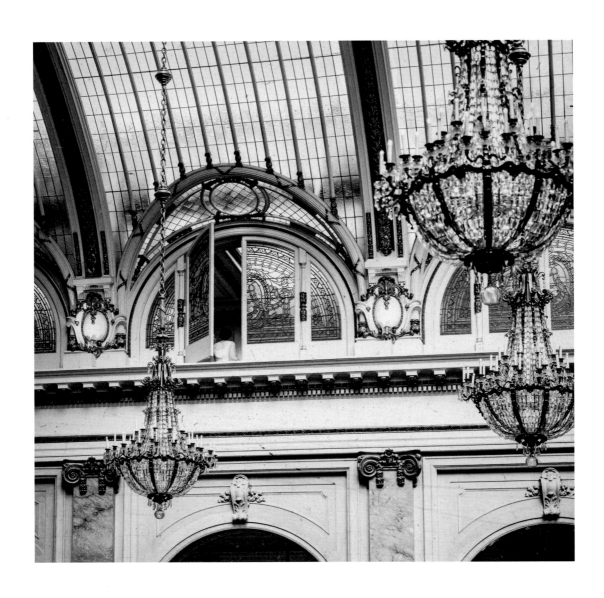

Preparing for a Speech, The Palace Hotel, San Francisco, California, 2018

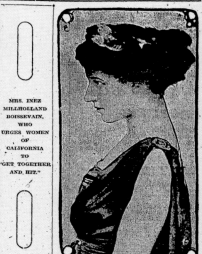

MRS. INEZ MILLHOLLAND BOISSEVAIN, WHO URGES WOMEN OF CALIFORNIA TO "GET TOGETHER AND HIT."

California Women Urged to Vote Against Democrats for Denying Freedom of Sex

SAN FRANCISCO, Oct. 21.—"Get together ladies, and hit."

This was the message brought to the women voters of the bay cities tonight by Mrs. Inez Milholland-Boissevain, of New York, one of the country's foremost suffrage leaders, speaking at the Palace Hotel on the National Women's party campaign, and advocating united Republican vote on the part of the four million enfranchised women of the United States.

Nearly 1500 persons, including a small sprinkling of men, listened for two hours to straight-from-the-shoulder hot shots poured into the Democratic camp by Mrs. Boissevain and when she had concluded they yelled, screamed and called for more.

TEARS INTO CANDIDATE.

Bringing as her dominant note the repudiation of Woodrow Wilson for his refusal of the women of the country asking the freedom of the ballot and the enfranchisement of their sisters, Mrs. Boissevain tore into the administration tooth and nail. Hers was a direct attack. It was not flamboyant nor loud nor pompous. It was a plain, quiet statement of the issues and contained an indictment of Democrats and Democratic sidestepping of issues which has seldom been so concretely put forward. Among other statements she said:

"You can not stand loyal to women's rights and vote for the Democratic party. If you stand together and pile up a protest vote, victory is sure—the long fight of sixty years is over. If you are united to another and defeat a party which ignored your claim to freedom the end of the long battle will be in sight. If you do not you betray the cause of women and postpone the victory. If you stand firm, whoever comes in on November 7, be he Democrat or Republican, will do what you want, because he will know your power. I don't care who is elected President of the United States, but I don't want the Democratic party swept into office on the votes of women. If we women stand together and register a big protest vote against President Wilson and the Democratic party which has betrayed us, we will get what we want. The world needs women just as women need activity and responsibility of citizenship.

PRAYS BOON OF SISTERS.

"I come to you as a messenger from the disfranchised women of the East, from the disfranchised women of the nation, organized in protest against their disfranchisement. Our message is directed to the voting women of the West. We women who are not yet citizens, who are not free, pray the boon of your hands. We ask a favor of you. We want you to set us free. We want you women

to enfranchise women. We want you women of the West to confer the freedom on the women of the East that freedom that you enjoy.

"We beg you to set the seal of your disapproval upon the Democratic party, the party that has denied the women's claim to self-government. No woman's, no loyal woman who respects her sex can give her support to the Democratic party which denied freedom to the women of the United States. We are opposed to the Democratic party because the Democratic party opposed suffrage. I propose to spread the record of the Democratic party for your consideration. It isn't a pretty record? I don't blame the Democrats for not wanting it known.

PRESIDENT'S BAD FAITH.

"The Democrats pushed the suffrage amendment to a vote realizing that defeat was certain. They blocked it in committee, they hitched it up with other amendments, the prohibition amendment, and some of its advocates were prevented from voting for it because of the measure it was tied to. They refused to put the party behind it. President Wilson refused to aid us. He refused fourteen times over in just as many excuses. He first said that there was nothing in his party platform about suffrage and he couldn't step outside the party platform. We believed him then, but after his refusal to help us he jammed through the Panama tolls bill which was outside and in direct contradiction to his early platform. We were amazed at his lack of faith. We said, 'Mr. President, why is there no freedom for women, you who say that you have almost a reckless enthusiasm for liberty?'

"'I believe in states' rights,' he replied, 'and therefore cannot and will not help you.' We believed him that time, too, but after his assertions he passes the child labor bill, the federal road bill, excellent measures, but why is there no federal legislation on a matter so fundamental to women?

"I only want you to know President Wilson, ladies, so that you can recognize him as the politician that he is and meet out to him just what he deserves. Get together, ladies, and hit. Hhat is sauce for the goose is sauce for the gander. If it's good for men to get together and combine, it's good for women."

NOT AFRAID OF HECKLERS.

Mrs. Boissevain told her audience when several attempts were made to interrupt her on the part of Wilson adherents, that she would stay all night, if necessary, to answer questions.

She was introduced by Mrs. Orlow Black of the reception committee and spoke from a platform set with flowers and bedecked with greens. Behind her was a huge banner bearing the motto, "National Women's Party. Has one plank—nation-wide suffrage for women."

Mrs. Boissevain is considered one of the most brilliant of the suffrage women of America. Her home is in New York and she is a graduate of the New York law school. Having married an alien, she herself is disqualified from citizenship.

Accompanying her on her tour are her sister, Mrs. Veda Milholland, and Mrs. C. C. Baker, a suffrage leader of Washington, D. C.

Oakland Tribune, California, October 22, 1916

Strategizing, The Palace Hotel, San Francisco, California, 2018

Room Key, The Palace Hotel, San Francisco, California, 2018

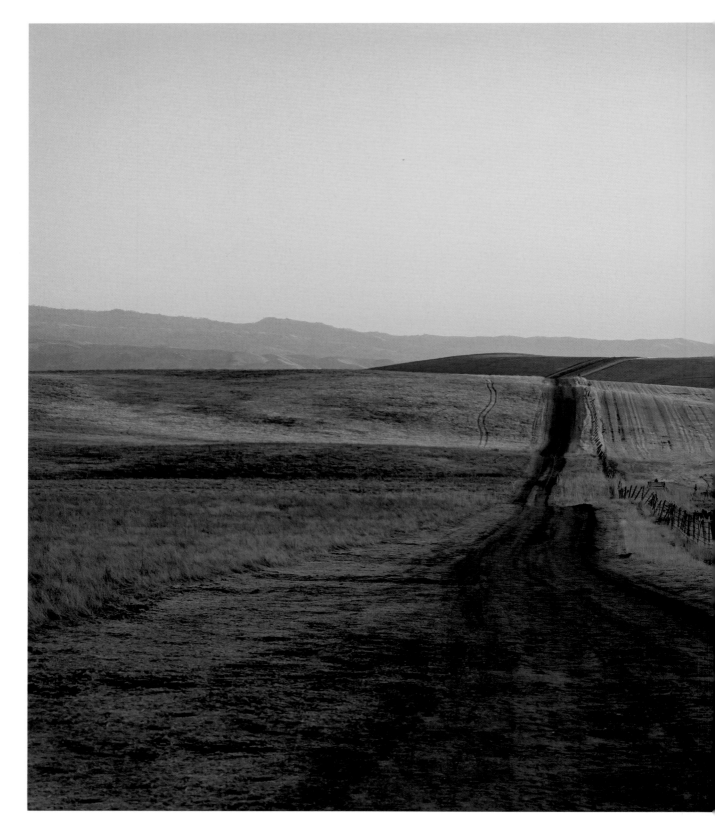

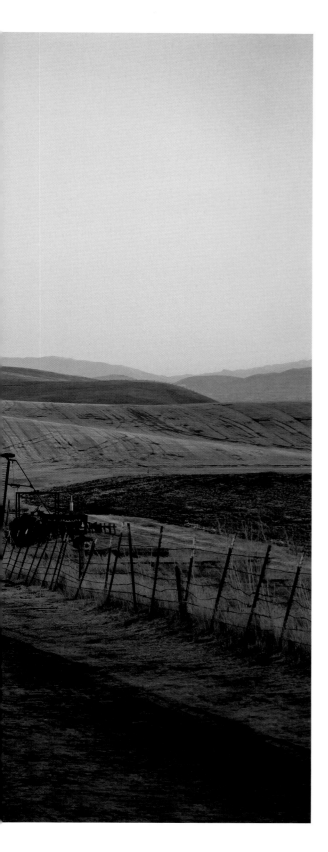

Back to the City, leaving Phoebe Hearst's Estate, Pleasanton, California, 2018

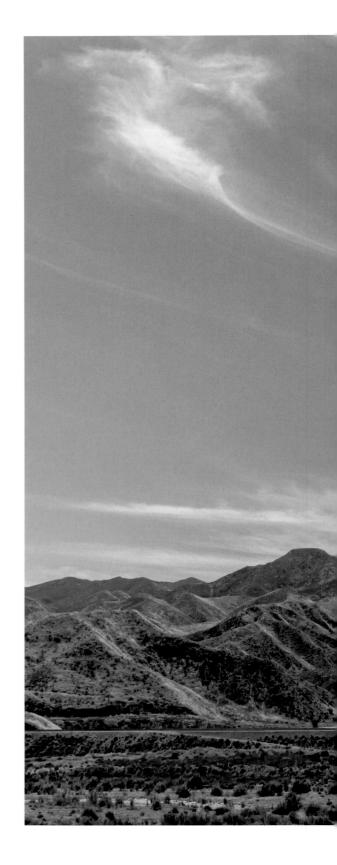

Continuing on to Los Angeles, San Gabriel Mountains, California, 2019

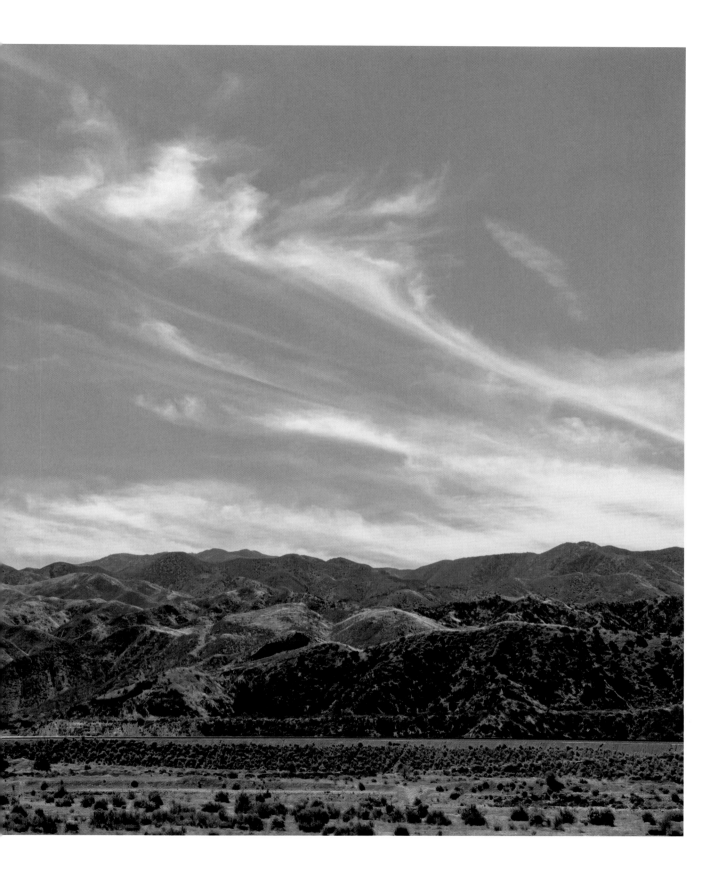

Fading Rose, 2019

Climax.

FAINTS AT HER HIGHEST POINT.

*Inez Milholland Boissevain
Falls on Platform.*

*Dramatic Scene in Midst of
Brilliant Address.*

*Why Suffragist is Against
Woodrow Wilson.*

With arm upraised, condemning President Wilson for his treachery to women, before one of the largest audiences Blanchard Hall has ever held, Inez Milholland Boissevain, the beautiful suffragist, fell in a dead faint on the platform last evening.

It was a dramatic scene. A moment before, this remarkable woman, the charms of whose personality have not been exaggerated, held the great audience with the fire and emotion of her oratory. In the middle of an intense sentence she crumpled up like a wilted white rose and lay stark upon the platform, while one of those eloquent silences befell the expectant crowd. Then the excitement broke out as doctors in the audience hastened to her assistance, and little Beulah Amadon, a dainty slip of an ardent suffragist, pleaded for calm and quiet.

While Mrs. Boissevain was being carried from the platform, this little lady held the audience playing for time. Reassurances were forthcoming, and eloquent excuses made, but e'er the audience departed, Inez Milholland insisted upon returning to the platform.

HER FIERY LOGIC.

With pale face and torn dress, she pleaded to be heard out. She was not, she said, fatigued with campaigning, it was not frail femininity overtaxing its strength, but a mere attack of tonsillitis, from which anyone might suffer. Mayor Mitchel of New York, she laughingly explained, had his attacks of malaria. Game to the end, she stood for another half hour, answering questions from the floor with fiery logic, amid the wild cheers of the audience.

Inez Milholland Boissevain is here to plead for the votes of women. "If you don't like our title, 'The Woman's Party,'" she said, "blame the men, not us. There are men's parties in thirty-six State, and this woman's party is designed to do away with sex parties forever.

"I come as a messenger from the disfranchised women of the nation," she said. "We are asking you to set us free. We have asked men in vain, nationally speaking. Never before have women had the opportunity of conferring freedom. . . . Lincoln and the Republican party freed the slaves. Alexander of Russia freed the serfs. You women voters have the opportunity to free us *now.*"

Then followed a damning indictment of the Democratic party and President Wilson's personal treachery to women. With irrefutable concl:sness, she summed up the record of the present administration in its attitude to women. With biting humor she recited President Wilson's various explanations as to why he was not prepared to support the national amendment, and scathingly she showed how for every excuse he had passed tantamount legislation against his own declared principles. First, the Panama Canal tolls against the "platform of his party"—his party platform being his first reason for not indorsing the women. Then, after his declared "passionate attachment for State rights," his second reason, came the Child Labor Bill, the Federal Roads Bill, the Merchant Marine Bill and the eight-hour law, all in defiance of State rights.

SCORES WILSON.

Finally, his "fear of the negro vote." Six million more white women than negro women, 2,000,000 more white women than the whole negro vote, she pointed out to the President. "Yes," he answered. "I know, but you see, my Southern Congressmen don't know."

"This," said the speaker, sorrowfully, "after his declared 'almost reckless enthusiasm for human liberty.'"

"President Wilson may be true to men," she said, "but he has not played fair with women, and that is why we are out to defeat him."

It was, said the speaker, by national amendment that the vote was given to the Indians, to the negroes, to the aliens. Is it then not good enough for American women?

Asked from the floor in how she was convinced that the Republican party would prove more faithful on the question of the amendment than the Democrats, Mrs. Boissevain reminded her hearers that it was true that Mr. Hughes had come out squarely and straightforwardly for national franchise for women, and that if they once appreciated that the 4,000,000 women voters were united on this question, no party would dare to repudiate it.

Mrs. Berthold Baruch presided as chairman of the meeting, and Mrs. Shelley Tolhurst introduced the "idol of the suffragettes."

In speaking of the fact that "Wilson has kept us out of war," Mrs. Tolhurst, after the cheers of the Democrats in the audience had died down, raised a hearty laugh by asking what nation had particularly wanted to make war upon us.

Mrs. Inez Boissevain,
Noted suffragette, who arrived here yesterday to champion votes for women.

VISE DEATH AWARD.

**Southern Pacific is Loser in Appeal
for a New Trial.**

United States District Judge Trippet yesterday overruled the motion of the defendant corporation for a new trial, in the action brought by Gertrude Wright against the Southern Pacific for damages resulting from the death of her husband, George R. Wright, at Selma, May 22, 1914.

Wright was driving an automobile truck, and while crossing a street was struck by a passing train and killed. The jury returned a verdict of $12,-000 for Mrs. Wright, one of the largest death verdicts rendered in California in a long time.

LITTLE THEATER OPENING.

The Players' Producing Company will present their initial offering, directed by Richard Ordynski, at the Little Theater Tuesday evening, the 31st. It will be the Russian drama "Nju," by Ossip Dymow. The time intervening will give Mr. Ordynski every opportunity to prepare the production in the careful, efficient manner which has done so much to place him in the position he now holds among the world's most capable directors of drama. Coupled with Mr. Ordynski's personal supervision of the play as a whole will be the work of Norman-Bel Geddes, whose originality in stage direction and lighting effects has done much to create the atmosphere necessary for the tense dramatic action of such a play as "Nju."

LECTURE ON BANKRUPTCY.

William H. Moore, Jr., trustee and receiver in bankruptcy, will give a special lecture course on the law of bankruptcy in the school of law of Southwestern University, beginning today. The course will consist of eight lectures, and will be given on Tuesday and Thursday evenings at 7:30 o'clock. An invitation is extended to the members of the bar of Los Angeles to attend the lectures.

ON DISTRICT APPOINTMENT.

The Vermont Boulevard Association will meet at 7:30 o'clock tomorrow night in the Chamber of Commerce assembly-room. The committee on the district apportionment plan will present its report, which will be discussed.

DINNER FOR FRUIT GROWERS.

Plans were completed today for a big dinner which will be participated in by all the exchange members of the Riverside district. G. Harold Powell, general manager of the California Fruit Growers' Exchange, will deliver the principal address at the gathering, which will be held at the Elks' Club House on the evening of November 2. Other speakers will include Don Francisco, advertising manager of the exchange; A. M. Montesano, manager of the Fruit Growers' Supply Company, and D. C. King, the exchange's orange sales agent.

SALES MANAGERS TO MEET.

The Sales Managers' Association of Los Angeles will have its next meeting and dinner at the Alexandria at 6:15 o'clock tomorrow evening.

Nerves All On Edge?

Just as nerve wear is a cause of kidney weakness, so is kidney trouble a cause of nervousness. Anyone who has a com

"President Wilson, how long must this go on, no liberty? Let me repeat—we are not putting our faith in any man or in any party but in the women voters of the West."

—Inez Milholland at Blanchard Hall, Los Angeles, October 24, 1916

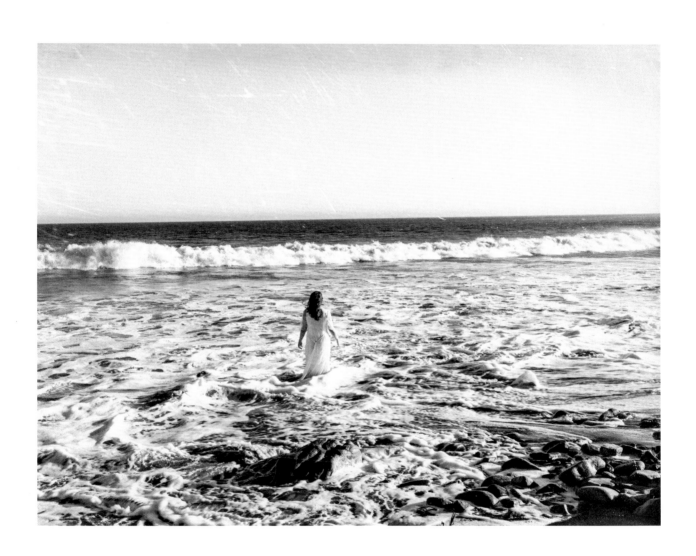

Transitioning, Los Angeles, California, 2019

Ladies & Gentlemen,
I suppose that
most of you ~~are here tonight,~~
~~because you~~ want to know
why women from New York
state have journeyed over
2000 miles ~~from~~ into the West
to talk to you about politics
Well, I doubt if we
would have come all
at this busy season of the year
that way, wonderful as
your country is with its
people full of good will
and the kindliest human
fellowship, if we did
not think our mission
of almost sacred

Appeal to the Women Voters of the West

Inez Milholland

The unenfranchised women of the nation appeal to you for help in their fight for political freedom. We appeal to you to help us, for you alone have both the power and will.

The dominant political party—the Democratic party—has the power to liberate the women of the United States, but they have refused to exercise that power on our behalf, and on behalf of justice and of freedom. They have refused to put the party machinery back of the constitutional amendment [*sic*]. They have blocked the amendment at every turn. The Democratic leaders in the Senate forced it to defeat through a premature vote. In the House they have buried it in committee. Fourteen times the President has refused to help.

Therefore, women of the West, let no free woman, let no woman that respects herself and womankind, lend her strength to the Democratic party that turns away its face from justice to the women of the nation.

Politically speaking, the women of America have been a weak and helpless class without the political pressure to push their demands.

Now, women of the free states, we are no longer helpless.

Now, for the first time in our history, women have the power to enforce their demands, and the weapon with which to fight for women's liberation. You, women of the West, who possess that power, will you use it on behalf of women? We have waited so long and so patiently and so hopelessly for help from other political sources. May we not depend upon the cooperation and good-will of women in

politics? Shall we not feel that women will respond to the appeal of women, and shall we not see their hands stretched out to us in sympathy and help?

Women of the West, stand by us now. Visit your displeasure upon that political party that has ignored and held cheaply the interests of women.

Let no party, whatsoever its name, dare to slur the demands of women, as the Democratic party has done, and come to you for your endorsement at the polls. Make them feel your indignation. Let them know that women stand by women. Show them that no party may deal lightly with the needs of women, and hope to enlist your support.

Women of the western states, it is only thus that we shall win.

It is only by unity, and common purpose, and common action, and by placing the interests of women above all other political considerations, until all women are enfranchised, that we shall deserve to win.

Liberty must be fought for. And, women of the nation, this is the time to fight. This is the time to demonstrate our sisterhood, our spirit, our blithe courage, and our will.

It is women for women now, and shall be till the fight is won.

Sisters of the West, may we count on You? Think well before you answer. Other considerations press upon you. But surely this great question of women's liberty comes first.

How can our nation be free with half of its citizens politically enslaved?

How can the questions that come before a government for decision, be decided aright, while half the people whom these decisions affect are mute?

Women of the West, stand by us in this crisis. Give us your help and we shall win. Fight on our side and liberty is for all of us. For the first time in the world women are asked to unite with women in a common cause. Will you stand by?

Women of the West, if you love and respect your sister women, if you hate unfairness and contempt, if you cherish self-respect, you must send the Democratic party which has abused the interests of women, down to defeat in the suffrage states in November.

Make it plain that neglect of women's interests and demands will not be tolerated. Show a united front, and, whatever the result in November, there never again will be a political party that will dare to ignore our claims.

You know that politicians act when it is expedient to act; when to act means votes, and not to act means loss of votes.

President Wilson made this plain when he supported the eight-hour day measure for railway workers. If he cared about principle *per se* he would himself have urged an eight-hour day. But this was not worth while. What is worth while is to act for those who have organization, unity, and political strength behind them.

We have but to exhibit organization, unity, and political strength, and victory is ours. More, I say only when we have done so, shall we deserve victory.

A handwritten and edited rough draft of Inez Milholland's "Appeal to the Women Voters of the West," ca. October 1916

The gods of government help those who help themselves.

Therefore, women and sisters, and one day fellow voters, let us help ourselves.

Say to the rulers of this nation:

"You deal negligently with the interests of women at your peril. As you have sowed so shall ye reap. We, as women, refuse to uphold that party that has betrayed us. We refuse to uphold any party until all women are free. We are tired of being the political auxiliaries of men. It is the woman's fight only we are making. Together we shall stand, shoulder to shoulder for the greatest principle the world has ever known—the right of self-government."

Not until that right is won shall any other interest receive consideration. This demand of ours is more urgent than all others. It is impossible for any problem that confronts the nation today to be decided adequately or justly while half the people are excluded from its consideration. If democracy means anything it means a right to a voice in government, and there is a reason for the conceded supremacy of that right.

Women are as deeply concerned as men in foreign policy. Whether we shall have a civil or militaristic future is of deepest moment to us. If things go wrong we pay the price—in lives, in money, in happiness.

We care about what sort of tariff we shall have. If the cost of living goes up, we, as housekeepers, are the ones to suffer.

We are deeply interested in the question of national service. We know, and must help to decide, whether our sons are to be trained to peace or war.

To decide these questions without us, questions that concern us as vitally as they concern men, is as absurd as would be an attempt to exclude the mother from influence in the home or care of her family.

We say to the government:

"You shall not embark on a policy of peace or war until we are consulted.

"You shall not make appropriations for the building of ships and engines of war, until we, who are taxed for such appropriations, give our consent.

"You shall not determine what sort of national defenses we shall have, whether civil or military, until we co-operate with you politically.

"You shall not educate our children to citizenship or soldierdom without our wisdom and advice.

"You shall no longer make laws that burden us with taxes and high prices, or that determine how our commodities shall be prepared and by whom, or that regulate our lives, our purchasing capacities, our homes, our transportation, and education of children, until we are free to act with you."

This is our demand.

This is why we place suffrage before all other national issues. This is why we will no longer tolerate government without our consent. This is why we ask women to rise in revolt against that party that has ignored the pleas of women

for self-government, and every party that ignores the claims of women, until we win.

Women of the West, will you make this fight? Will you take this stand? Will you battle for your fellow women who are not yet free?

We have no one but you to depend on. Men have made it plain that they only fight for us when it is worth their while, and you must make it worth their while. You must ignore that party that has ignored women, and demonstrate to all future parties that it is dangerous to do so.

It is only for a little while. Soon the fight will be over. Victory is in sight. It depends upon how we stand this coming election—united or divided—whether we shall win and whether we shall deserve to win.

We have no money, no elaborate organization, no one interested in our success, except anxious-hearted women all over the country who cannot come to the battle line themselves.

Here and there in farm house and factory, by the fire-side, in the hospital, and school-room, wherever women are sorrowing and working and hoping, they are praying for our success.

Only the hopes of women have we; and our own spirit and a mighty principle.

Women of these states, unite. We have only our chains to lose, and a whole nation to gain. Will you join us by voting against President Wilson and the Democratic candidates for Congress?

This text appeared in *The Suffragist* 4, no. 42 (October 14, 1916), pp. 8–9.

Inez Milholland's Western Campaign Itinerary

Wednesday, October 4, 1916
Leaves New York City by train to Chicago

Thursday, October 5, 1916
Arrives in Chicago
Meets with reporters and visits the National Woman's Party headquarters on State St.
Dines at the Blackstone Hotel with her sister Vida and their father, John Milholland
Leaves Chicago after dinner by train for Cheyenne, Wyoming

Friday, October 6, 1916
En route to Cheyenne

Saturday, October 7, 1916
Arrives in Cheyenne after midnight
Speaks in the afternoon at the Plains Hotel along with Harriot Stanton Blatch, and Vida sings

Sunday, October 8, 1916
Leaves Cheyenne by train in a private car for Pocatello, Idaho
Stops briefly in Green River, Wyoming, where a group is waiting for her at the station
Stops in Montpelier, Idaho, where she gives a speech from the train's rear platform
Arrives in Pocatello, Idaho, where she attends a revival, eats at the hotel café, and stays in the Yellowstone Hotel

Monday, October 9, 1916
Gives a speech with Sara Bard Field, a poet and fellow suffragist, at the Yellowstone Hotel. It is so crowded that three hundred men stand outside the venue, giving their indoor spots to women
Leaves Pocatello on the mail train, which lacks a dining car, for Boise, Idaho
Whistlestop speech in Glenns Ferry, Idaho
Continuing on to Boise, has an impromptu suffrage meeting on the train
Speaks at the Pinney Theatre along with Sara Bard Field to an audience of nearly two thousand

Tuesday, October 10, 1916
Leaves Boise by train in the middle of the night for Portland, Oregon
Stops in Pendleton, Oregon, where she gives a whistlestop speech
Leaves Pendleton by train for The Dalles, Oregon, where a crowd, including Native Americans, gathers to hear her speak from the train
Leaves The Dalles by train for Hood River, Oregon, where a number of women greet her at the train
Leaves Hood River by train for Medford, Oregon
Afternoon meeting at Medford Carnegie Public Library
Leaves Medford by train for Grants Pass, Oregon, where an enthusiastic crowd greets her
Arrives in Portland, where reporters and photographers are waiting at the train station
Attends a banquet for five hundred people at the Multnomah Hotel; two hundred people are turned away

Wednesday, October 11, 1916
Leaves Portland in the early morning by train for Seattle, Washington
Attends a luncheon with one hundred of Seattle's prominent citizens at the Sunset Club
Speaks in the afternoon at Northwest Products Expo
Attends a dinner with 160 guests in her honor at the Sunset Club
Speaks at a nighttime meeting at Moore Theatre, which has an audience of about three thousand

Thursday, October 12, 1916
Leaves Seattle by automobile to Tacoma, Washington
Gives a speech at the Tacoma Hotel
Attends a luncheon given by Mrs. W. P. Trowbridge
Returns to Seattle by automobile, then leaves by overnight train to Spokane, Washington

Friday, October 13, 1916
Arrives in Spokane
Attends an afternoon reception at the home of Mrs. Austin Corbin II, where she shakes hands with several hundred women
Gives a speech at the Strand Theater to a standing-room-only crowd of around 1,800 people; she is introduced by Mrs. Nettie Rice, president of the Spokane branch of the National Woman's Party (NWP)
Leaves Spokane late at night by train for Shelby, Montana

Saturday, October 14, 1916
Arrives at Cut Bank, Montana, where she gives a whistlestop speech
Continues on train from Cut Bank to Shelby, Montana, where she attends a street rally

Leaves Shelby for Great Falls, Montana

Arrives at dusk in Great Falls, where her train is met by the Black Eagle Band; an auto caravan takes her to the Palace Theatre, where she gives an evening speech to an audience of about one thousand

Sunday, October 15, 1916

Leaves Great Falls by train for Helena, Montana

Attends an afternoon reception in the ballroom of the Placer Hotel

Speaks at a meeting at the Unitarian church

Leaves Great Falls by train for Butte, Montana

Arrives at night and gives an interview at the Thornton Hotel

Monday, October 16, 1916

Takes a morning tour through the Leonard Mine

Speaks at the Silver Bow Club, where nearly one hundred people attend a luncheon

Leaves Butte by train in the early evening for Ogden, Utah

Tuesday, October 17, 1916

Arrives at dawn in Ogden

Stands in a receiving line of about one hundred people and speaks at a luncheon at Berthana Hall

Speaks at the Orpheum Theatre, where about three hundred women and fifty men attend

Leaves Ogden by train in the evening for Salt Lake City, Utah

Speaks at the Salt Lake Theater to a full house, along with the suffragist Helen M. Todd

Leaves Salt Lake City late at night by train for Ogden, Utah

Wednesday, October 18, 1916

Arrives in Ogden for a brief rest at a hotel

Leaves Ogden by train and is met at a remote station by Anne Martin, NWP Chair; proceeds to Winnemucca, Nevada, by automobile

Attends a mass meeting at the Nixon Opera House

Thursday, October 19, 1916

Leaves in the middle of the night from Winnemucca by train to Reno, Nevada

Arrives in Reno, where she is met by prominent members of the NWP and escorted to the Riverside Hotel

Leaves Reno in the afternoon by automobile to Virginia City, Nevada

Speaks at a street rally attended by five hundred and is welcomed by mine and fire whistles blowing and school bells ringing; after the rally women rush to the town hall to register to vote

Leaves Virginia City by automobile to Silver City, Nevada

Gives a speech at an evening street meeting in front of the Central Telephone office

Leaves Silver City by automobile for Carson City, Nevada

Arrives after dark and speaks for over one hour at the Grand Theatre

Friday, October 20, 1916

Leaves Carson City by automobile in the early morning for Reno

Attends an afternoon reception in her honor at the home of Mrs. George H. Taylor

Gives a speech in the evening at the Majestic Theater, which is filled to capacity

Escorted to the train station by a large crowd; leaves Reno by train in the late evening for Sacramento, California

Saturday, October 21, 1916

Arrives in Sacramento in the morning

Is met by members of the Chamber of Commerce and taken on a tour of the city as part of an auto parade

Speaks at a luncheon and a later meeting at the Sacramento Hotel, where she shares the podium with Maud Younger, a NWP lobbyist who helped win the vote for women in California, and who later spoke at Milholland's memorial service in Washington, D.C.

Leaves Sacramento in the afternoon by train for San Francisco

Speaks in the ballroom of the Palace Hotel to a crowd of 1,500; an equal number are turned away

Sunday, October 22, 1916

Leaves San Francisco by automobile for Pleasanton, California

Has afternoon tea at the estate of Phoebe Apperson Hearst, Vice Chairwoman of NWP and mother of newspaper magnate William Randolph Hearst

Returns to San Francisco by automobile in the evening

Monday, October 23, 1916

Leaves San Francisco by train in the early morning for Los Angeles

Speaks at Blanchard Hall to about one thousand people; one hundred more are turned away

Collapses onstage while speaking and is carried away, but returns fifteen minutes later to finish her speech, seated in a chair

Tuesday, October 24, 1916

Dr. Catherine Lynch examines her at the Alexandria Hotel in Los Angeles

She is admitted to Good Samaritan Hospital, where her health continues to decline until she dies on November 25, 1916

Timeline of Suffrage in the United States

1776

The Declaration of Independence is signed, restricting the right to vote to white, male property owners.

In New Jersey, women and African American people win the right to vote.

1787

The United States Constitution is adopted; no federal voting standards are established.

Women in all states, except New Jersey, lose the right to vote.

1790

Naturalization Law limits citizenship to free whites.

1791

The Tenth Amendment to the Constitution, as part of the Bill of Rights, is ratified, allowing the states to regulate their own voting laws.

1807

New Jersey restricts voting to white male citizens.

1848

Seneca Falls, New York, is the location for the first women's rights convention. The resolution demanding women's right to vote barely passed.

1866

The American Equal Rights Association is formed "to secure Equal Rights to all American citizens, especially the right of suffrage, irrespective of race, color, or sex."

1868

The Fourteenth Amendment is ratified, granting citizenship to all persons "born or naturalized in the United States."

1869

National Woman Suffrage Association (NWSA) and American Woman Suffrage Association (AWSA) are founded.

In Wyoming Territory, women win the right to vote.

1870

In Utah Territory, women win the right to vote.

The Fifteenth Amendment is adopted, giving African American men the right to vote.

1872

In Rochester, New York, Susan B. Anthony registers, votes, and is arrested.

In Grand Rapids, Michigan, Sojourner Truth demands a ballot at a polling booth and is turned away.

1874

The Woman's Christian Temperance Union is founded to moderate alcohol consumption and becomes a key component of the women's suffrage movement.

1875

In *Minor v. Happersett*, the Supreme Court rules unanimously that the right to vote is not "one of the privileges and immunities of citizenship" protected by the Fourteenth Amendment.

1878

A Woman Suffrage Amendment is proposed in Congress and fails. Yet the wording is retained and used forty-one years later as part of the Nineteenth Amendment.

1880

Women win school suffrage in New York State. Here and in other states, school suffrage is often the gateway to winning broader voting rights.

1882

The Senate appoints a Select Committee on Woman Suffrage that finds in favor of the enfranchisement of women, but it does not vote on the measure.

1887

In the Territory of Montana, women win the right to vote.

Congress passes the Edmunds-Tucker Act, which, among other things, disenfranchises the women of Utah Territory.

1890

After several years of negotiations, the NWSA and the AWSA merge to form the National American Woman Suffrage Association (NAWSA).

Wyoming joins the Union as the first state with voting rights for women.

1893

In Colorado, women win the right to vote.

1896

In Idaho, women win the right to vote.

Utah joins the Union as the forty-fifth state and reinstates women's voting rights.

1898

Mary Church Terrell addresses the NAWSA convention, challenging white suffragists not to abandon their African American sisters.

1904

The International Woman Suffrage Alliance forms to campaign for women's suffrage worldwide.

1907

The Expatriation Act passes, mandating that "any American woman who marries a foreigner shall take the nationality of her husband" and lose her American voting rights if applicable.

1908

The first street parade for women's suffrage is organized by the Harlem Equal Rights League in New York.

1910

In the state of Washington, women win the right to vote.

1911

In California, women win the right to vote.

The National Association Opposed to Woman Suffrage is founded.

1912

Women win the right to vote when suffrage referendums are passed in Arizona, Kansas, and Oregon.

Theodore Roosevelt's Progressive "Bull Moose" Party is the first major national party to include women's suffrage in its platform.

Two suffrage parades are organized in New York City.

1913

Women win the right to vote in the Territory of Alaska and the ability to vote in presidential elections in Illinois.

Alice Paul and Lucy Burns organize a suffrage parade in Washington, D.C., the day before Woodrow Wilson's inauguration.

Ida B. Wells-Barnett organizes the first suffrage club for African American women in Chicago, the Alpha Suffrage Club.

The Congressional Union for Woman Suffrage is formed by Alice Paul and Lucy Burns to campaign for a constitutional amendment guaranteeing women's suffrage.

1914

In Montana and Nevada, women win the right to vote.

1915

State women's suffrage referendums are defeated in New Jersey, New York, Pennsylvania, and Massachusetts.

1916

Jeannette Rankin, Republican of Montana, becomes the first woman to serve in Congress.

The National Woman's Party (NWP) is formed by Alice Paul and Lucy Burns as an outgrowth of the Congressional Union to fight for women's suffrage, which supersedes all other issues.

The Western Campaign is launched by the NWP.

Carrie Chapman Catt reveals her "winning plan" to achieve victory by focusing on promising state campaigns—none of which are Southern states—lobbying for a federal suffrage amendment and building support for future ratification efforts.

1917

Women win full voting rights in New York and the ability to vote in presidential elections in Indiana, Michigan, Nebraska, North Dakota, Ohio, and Rhode Island.

Women win the right to vote in primary elections in Arkansas.

Members of the NWP are arrested and jailed for picketing the White House. When they go on a hunger strike, they are force-fed.

1918

Women win the right to vote in Michigan, Oklahoma, and South Dakota.

The House of Representatives passes a resolution in favor of a women's suffrage amendment, but it is defeated in the Senate.

1919

Women win the right to vote in presidential elections in Iowa, Maine, Minnesota, Missouri, Tennessee, and Wisconsin.

The Nineteenth Amendment, granting women the vote, is adopted and sent to the states for ratification.

1920

Tennessee becomes the thirty-sixth and final state to ratify the Nineteenth Amendment.

The Nineteenth Amendment is adopted on August 26.

The League of Women Voters is founded.

1923

The Equal Rights Amendment (ERA) is proposed to guarantee equal legal rights for all American citizens regardless of sex. It is meant to remedy inequalities not addressed in the Nineteenth Amendment.

1924

The Indian Citizenship Act is passed, granting citizenship to all Native Americans born in the United States. The right to vote, however, was governed by state law and not guaranteed in every state until 1962.

1935–36

Mary McLeod Bethune is the founding president of the National Council of Negro Women and appointed as a special advisor on minority affairs by President Franklin D. Roosevelt.

1940

The Nationality Act of 1940 reserves citizenship for whites and persons of African and Native American descent.

1962

Utah is the last state to guarantee voting rights for Native Americans.

1964

The Civil Rights Act passes and the Twenty-Fourth Amendment becomes law, making poll taxes illegal in federal elections.

1965

The Voting Rights Act of 1965 becomes law, removing legal barriers at the state and local levels that prevented African Americans from exercising their right to vote as guaranteed under the Fifteenth Amendment. Section 2 of the Act applied a nationwide prohibition against the denial or abridgment of the right to vote in federal elections based on literacy tests.

1966

The Supreme Court bans poll taxes in state elections.

1968

Shirley Chisholm, Democrat of New York, is the first African American woman to serve in Congress.

1970

The United States Congress extends Section 5 of the Voting Rights Act for five years, which allows for enforcement in areas of the country, primarily Southern states, where Congress believed the potential for discrimination to be the greatest.

1971

The Twenty-Sixth Amendment passes, lowering the voting age to eighteen.

1972

After nearly fifty years, the ERA is passed and moves to the ratification phase.

1974

Ella Grasso, Democrat of Connecticut, becomes the first woman elected Governor not having succeeded her husband in the position.

1975

The Voting Rights Act is amended to include protection of voting rights for non-English speaking American citizens.

Section 5 of the Voting Rights Act is extended for another seven years.

1981

Sandra Day O'Connor is the first woman to serve as a Supreme Court justice.

1982

The deadline for ERA ratification expires, falling short by three of the thirty-eight states required for its adoption.

Section 4 of the Voting Rights Act is extended for twenty-five years, continuing to use a formula that identifies areas prone to racial discrimination in voting.

1984

Geraldine Ferraro, Democrat of New York, is the first woman from a major political party nominated to be Vice President.

1993

The National Voter Registration Act passes, requiring states to offer voter registration opportunities at the Department of Motor Vehicles and public assistance and disability agencies.

2000

A federal court decides that residents of U.S. territories—including Puerto Rico, Guam, American Samoa, and the U.S. Virgin Islands (nearly 4.1 million total people)—are citizens, but are prohibited from voting.

2001

The National Commission on Federal Election Reform recommends that all states allow felons to regain their right to vote after completing their criminal sentences. Nearly four million U.S. citizens are prohibited from voting based on past felony convictions.

2006

The Voting Rights Act Reauthorization and Amendments Act of 2006 extends the prohibition of the use of tests or devices to deny the right to vote and the requirement for certain states to provide voting material in multiple languages for twenty-five years.

2009

The Military and Overseas Voter Empowerment Act passes, making voting more accessible for citizens who are abroad when elections take place.

2013

The Supreme Court strikes down a key provision of the Voting Rights Act, ruling that it is unconstitutional to require states with a history of voter discrimination—at the time, Alabama, Alaska, Arizona, Georgia, Louisiana, Mississippi, South Carolina, Texas, and Virginia—to seek federal approval before changing their election laws.

2017

Nevada is the thirty-sixth state to ratify the ERA.

2018

Illinois is the thirty-seventh state to ratify the ERA.

2020

Virginia is the thirty-eighth and final state needed to ratify the ERA.

The House of Representatives passes HJ79, a joint resolution to remove the original time limit assigned to the ERA.

Kamala Harris is the first woman, and first woman of color, to be elected as Vice President.

Bibliography

This bibliography includes the primary source material for *Standing Together*. The library of information that addresses the life of Inez Milholland and the long struggle for suffrage, however, is vast. A more extensive bibliography, along with lesson plans and other educational material, is available at the Standing Together project website, www.standingtogether-project.com.

Archives and Libraries

Inez Milholland Papers, 1906–1916. Arthur and Elizabeth Schlesinger Library on the History of Women in America, Radcliffe Institute for Advanced Study, Harvard University.

John E. Milholland Papers, Ticonderoga Historical Society, Ticonderoga, New York.

National Museum of American History and Culture, Smithsonian Institution.

National Woman's Party Collection at the Belmont-Paul Woman's Equality National Monument, Washington, D.C.

Newspaper and Current Periodical Division, Library of Congress.

Records of the National Woman's Party, Manuscript Division, Library of Congress.

Women's Franchise League of Indiana, Correspondence 1911–1915, M612, William H. Smith Memorial Library, Indiana Historical Society.

Women Suffrage Media Project, Robert P.J. Cooney, Jr. (private collection).

Books

Baker, Jean H. *Votes for Women: The Struggle for Suffrage Revisited*. New York: Oxford University Press, 2002.

Bausum, Ann. *With Courage and Cloth, Winning the Fight for a Woman's Right to Vote*. Washington, D.C.: National Geographic Society, 2004.

Benjamin, Anne Myra. *Women Against Equality, A History of the Anti-Suffrage Movement in the United States from 1895 to 1920*. Lewiston, NY: Edwin Mellen Press, 1991.

Berson, Robin Kadison. *Marching to a Different Drummer: Unrecognized Heroes of American History*. Westport, CT: Greenwood Press, 1994.

Blight, David W. *Frederick Douglass: Prophet of Freedom*. New York: Simon & Schuster, 2018.

Bordewich, Fergus M. *Bound for Canaan: The Epic Story of the Underground Railroad, America's First Civil Rights Movement*. New York: Amistad, 2005.

Catt, Carrie Chapman and Nettie Shuler. *Woman Suffrage and Politics: The Inner Story of the Suffrage Movement*. New York: Charles Scribner's Sons, 1923.

Cooney, Robert P. J., Jr. *Winning The Vote: The Triumph of the American Woman Suffrage Movement*. Santa Cruz, CA: American Graphic Press, 2005.

——. *Remembering Inez: The Last Campaign of Inez Milholland, Suffrage Martyr*. Santa Cruz, CA: American Graphic Press, 2015.

Cott, Nancy. *The History of Women in the United States: Women Suffrage*. Parts 1 and 2. Berlin: De Greuter, 1994.

Ford, Linda G. *Iron-Jawed Angels: The Suffrage Militancy of the National Woman's Party, 1912–1920*. Lanham, MD: University Press of America, 1991.

Fradin, Dennis Brindell and Judith Bloom Fradin. *Ida B. Wells, Mother of the Civil Rights Movement*. New York: Clarion, 2000.

Fuller, Margaret. *Woman in the Nineteenth Century*. Mineola, NY: Dover Publications, 1999. First published 1845 by Greeley & McElrath (New York).

Graham, Sara Hunter. *Woman Suffrage and the New Democracy*. New Haven: Yale University Press, 1996.

Ginzberg, Lori D. *Elizabeth Cady Stanton, An American Life*. New York: Hill and Wang, 2009.

Griffith, Elisabeth. *In Her Own Right, The Life of Elizabeth Cady Stanton*. New York: Oxford University Press, 1984.

Gurko, Miriam. *The Ladies of Seneca Falls: The Birth of the Woman's Rights Movement*. New York: Schocken Books, 1976.

Harned, Richard. *Images of America: The Palace Hotel*. Charleston, SC: Arcadia Publishing, 2009.

Irwin, Inez Haynes. *The Story of Alice Paul and the Woman's Party*. Edgewater, FL: Denlinger's Publishers, 1977. First published 1921 by Harcourt, Brace (New York).

Lemay, Kate Clarke. *Votes for Women! A Portrait of Persistence*. Washington, D.C.: Smithsonian Institution and Princeton, NJ: Princeton University Press, 2019.

Lumsden, Linda J. *Inez: The Life and Times of Inez Milholland*. Bloomington: Indiana University Press, 2004.

National American Woman Suffrage Association. *Victory: How We Won It. A Centennial Symposium 1840–1940*. New York: H. W. Wilson, 1940.

Ruth, Janice E. and Evelyn Sinclair. *Women Who Dare: Women of the Suffrage Movement*. San Francisco: Pomegranate, 2006.

Sherr, Lynn. *Failure is Impossible: Susan B. Anthony in Her Own Words*. New York: Times Books, 1995.

Solomon, Martha M., ed. *A Voice of their Own: The Woman Suffrage Press, 1840–1910*. Tuscaloosa: University of Alabama Press, 1991.

Stanton, Elizabeth Cady, Susan B. Anthony, Matilda Joslyn Gage, and Ida Husted Harper, eds. *The History of Woman Suffrage*. 6 vols. 1881–1922. Reprint ed. Salem, NH: Ayer, 1985. First published 1887.

Steele, Carole MacRobert. *Phoebe's House. A Hearst Legacy*. Eugene, OR: Luminare Press, 2016.

Stevens, Doris. *Jailed for Freedom: The Story of the Militant American Suffragist Movement*. New York: Black Dog & Leventhal, 2020. First published 1920 by Boni & Liveright (New York).

Terborg-Penn, Rosalyn. *African American Women in the Struggle for the Vote, 1850–1920*. Bloomington: Indiana University Press, 1998.

Washington, Margaret, ed. *Narrative of Sojourner Truth*. New York: Vintage, 1993. First published 1850.

Weiss, Elaine. *The Woman's Hour: The Great Fight to Win the Vote*. New York: Penguin Books, 2018.

Films, Videos, and Audio

Burns, Ken and Paul Barnes. *Not for Ourselves Alone*. New York: Florentine Films and Arlington, VA: WETA, 2004.

Reed, Miriam and The Homespun Singers. *Hurrah for Woman Suffrage: Songs of the Woman Suffrage Movement, 1848–1920*. Miriam Reed Productions, 1995.

Wheelock, Martha. *Inez Milholland. Forward into Light*. Studio City, CA: Wild West Women, 2016.

Articles

"Beautiful Inez Agin [*sic*] Wilson but Not Very Ardent for Hughes." *Tacoma Times* (WA), October 13, 1916.

"Beautiful Inez in California This Week for Hughes." *Santa Cruz Evening News* (CA), October 17, 1916.

"Big Crowd Hears Mrs. Boissevain." *Spokane Daily Chronicle*, October 14, 1916.

"Brilliant Suffrage Leader Holds Wilson to Answer." *Oakland Tribune*, October 22, 1916.

"Dainty Maidens Page Suffragist." *Oakland Tribune*, October 21, 1916.

"Death unto Party That Shall Ignore Suffragists, Is Cry." *Oregon Daily Journal* (Portland), October 11, 1916.

"Defiance Flavors Mrs. Boissevain's Appeal." *San Francisco Chronicle*, October 22, 1916.

"Democrats on Run, Says Mrs. Boissevain." *San Francisco Examiner*, October 22, 1916.

"Draws Good-Sized House but Fails in Making Impression." *Carson City Daily Appeal* (NV), October 20, 1916.

"Faints at Her Highest Point." *Los Angeles Daily Times*, October 24, 1916.

"Famous Suffrage Beauty to Talk at Majestic Theater This Evening." *Reno Evening Gazette*, October 20, 1916.

"Famous Suffragist Arrives in Butte." *Anaconda Standard* (MO), October 16, 1916.

"Famous Woman Spoke at Pocatello." *Kemmerer Republican* (WY), October 13, 1916.

"Great Meeting for Women at Theater." *Salt Lake Tribune*, October 16, 1916.

"Hard Words for President Today." *Sacramento Union*, October 20, 1916.

"Here's Sisterly Gossip about Mrs. Boissevain, the Suffrage Speaker." *Idaho Statesman* (Boise), October 10, 1916.

"'I Don't Care Anything About Hughes!'" *Helena Independent* (MO), October 16, 1916.

"Inez Boissevain Speaks Tonight." *San Francisco Examiner*, October 21, 1916.

"Inez Emphatic Undemocratic." *Great Falls Daily Tribune* (MO), October 15, 1916.

"Inez Milholland Boissevain May Undergo Operation on Her Throat." *San Francisco Chronicle*, October 26, 1916.

"Inez Milholland Boissevain to Speak Here October 25." *Arizona Republican* (Phoenix). October 22, 1916.

"Inez Milholland Is Coming." *Ogden Examiner* (UT), October 16, 1916.

"Leader in Cause of Equal Rights Brings Message." *San Francisco Chronicle*, October 21, 1916.

"'Make Choice' Women Plead." *Herald-Republican* (Salt Lake City), October 18, 1916.

"Many Turn Out to Hear the Beauty." *Cut Bank Pioneer Press* (Cut Bank, MO), October 20, 1916.

"Mrs. Boissevain Arrives for Reception." *Butte Miner* (MO), October 16, 1916.

"Mrs. Boissevain Exposes Falsity of Democrats." *Reno Evening Gazette*, October 21, 1916.

"Mrs. Boissevain Faints on Stage at L.A. Meeting." *San Francisco Examiner*, October 25, 1916.

"Mrs. Boissevain Honored at Tea." *Spokesman-Review* (Spokane), October 14, 1916.

"Mrs. Boissevain Ill." *Daily Capital Journal* (Salem, OR), October 26, 1916.

"Mrs. Boissevain in Utah, Battling for Suffrage." *Herald-Republican* (Salt Lake City), October 17, 1916.

"Mrs. Boissevain Is Fighting Wilson." *San Francisco Chronicle*, October 15, 1916.

"Mrs. Boissevain Is Resting from Strain." *Oakland Tribune*, October 27, 1916.

"Mrs. Boissevain Off Today." *New York Times*, October 4, 1916.

"Mrs. Boissevain Too Ill to Make Speeches." *San Francisco Chronicle*, October 25, 1916.

"Mrs. Hearst to Receive Suffragist." *San Francisco Examiner*, October 20, 1916.

"Mrs. I. M. Boissevain Asks Protest Vote." *Nevada State Journal* (Reno), October 20, 1916.

"Mrs. Inez Boissevain Is Operated on Here." *Los Angeles Times*, October 27, 1916.

"Mrs. Inez Milholland Boissevain Will Speak at Majestic Tonight." *Nevada State Journal* (Reno), October 20, 1916.

"Nation-Famed Women to Speak at Meeting at Pinney Theater." *Idaho Statesman* (Boise), October 8, 1916.

"National Suffrage Is Theme of Mrs. Boissevain." *Salt Lake Telegram*, October 18, 1916.

"Noted Leader Coming. Pleads for Suffrage. Is Supporting G.O.P." *Herald-Republican* (Salt Lake City), October 15, 1916.

"Noted Suffragist Cordially Received." *Nevada State Journal* (Reno), October 21, 1916.

"Our Suffrage Visitors." *Salt Lake Telegram*, October 18, 1916.

"Policemen Stand and Laugh While Women of Chicago, in Making Silent Protest as to Wilson's Suffrage Stand, Are Badly Beaten." *Nevada State Journal* (Reno), October 20, 1916.

"Rally Is Held by the Women's Party." *Salt Lake Tribune*, October 18, 1916.

"Says Women Will Defeat President." *Salt Lake Tribune*, October 18, 1916.

"Suffrage Beauty Is Welcomed to Reno." *Reno Evening Gazette*, October 19, 1916.

"Suffrage Beauty Who Is to Deliver Address in Cheyenne Next Saturday." *Wyoming Tribune* (Cheyenne), October 6, 1916.

"Suffrage Belle Stumps Country." *Oregon Statesman* (Salem), October 7, 1916.

"Suffrage Is Demand of Leaders." *San Bernardino News* (CA), October 23, 1916.

"Suffrage Leaders Making Great Campaign in Support of Hughes." *Casper Daily Tribune* (WY), October 10, 1916.

"Suffrage Plea Made." *Sacramento Union*, October 22, 1916.

"Suffragist Improves." *Los Angeles Sunday Times*, October 29, 1916.

"Urges Women of West to Show Power of Their Votes." *Spokesman-Review* (Spokane), October 14, 1916.

"Wants Law to Force Husbands to Divide Cash." *Chicago Daily Tribune*, October 6, 1916.

"Wilson Calls the Women His Fellow Citizens." *Sacramento Union*, October 20, 1916.

"Wilson's Defeat Not Sought by Women." *Butte Miner* (MO), October 17, 1916.

"Woman Leader Declares Wilson Is Not Sincere." *San Francisco Chronicle*, October 20, 1916.

"Woman Party Leader to be Guest in Butte." *Anaconda Standard* (MO), October 12, 1916.

"Woman Plays Her Part in the News." *Oakland Tribune*, October 26, 1916.

"Woman's Party Leaders to Be Here." *Butte Miner* (MO), October 14, 1916.

"Woman's Party to Have Big Rally." *Ogden Standard* (UT), October 14, 1916.

"Woman Ranks High." *Sunday Oregonian* (Portland), October 8, 1916.

"Women Outline Political Views." *Kemmerer Republican* (WY), October 27, 1916.

"Women to Telephone Vote Against Wilson." *Los Angeles Daily Times*, October 23, 1916.

"Women Voters Demand Right in East State." *Nevada State Journal* (Reno), October 20, 1916.

"Women Will Hold Mass Meeting at Boise." *Caldwell Tribune* (ID), October 6, 1916.

Online Resources

2020 Women's Vote Centennial Initiative. www.2020Centennial.org

Belmont-Paul Women's Equality National Monument. National Park Service. www.nps.gov/bepa/index.htm

National Women's History Museum. www.womenshistory.org

Turning Point Suffragist Memorial. suffragistmemorial.org

National Women's History Alliance. www.nationalwomenshistoryalliance.org

National Women's History Museum. www.womenshistory.org

History's Women: The Unsung Heroines. www.historys-women.com

Remembering Inez: The Last Campaign of Inez Milholland, Suffrage Martyr. www.rememberinginez.com

Lesson Plans

Teaching the 19th Amendment, National Park Service. www.nps.gov/subjects/womenshistory/teach-19th-amendment.htm

Suffrage School at Harvard/Radcliffe Institute. www.radcliffe.harvard.edu/suffrage-school#field

Editor's Note

On the Texts

The information presented in the essay "Forward Together," the timeline of suffrage, and Inez Milholland's itinerary were compiled from a broad array of sources, including libraries, archives, books, and newspaper articles, many of which are listed in the bibliography. We have, to the best of our abilities, verified the factual information contained in this book. Direct quotations in "Forward Together" are cited in the notes at the end of the essay. Complete citations for factual elements of the events presented in the essay can be found on the project website, www.standingtogether-project.com. In addition to the sources of the citations in "Forward Together," the quotations in the plate section of the book, and the bibliography, newspaper stories on Milholland's campaign were published in regional papers including the *Atchison Champion* (Atchison, KS), *Daily East Oregonian* (Pendleton), *Dodge City Kansas Journal*, *Evening News* (Roseburg, OR), *La Grande Observer* (OR), *Goodwin's Weekly* (Salt Lake City), *Greensboro Daily News* (NC), *Hood River Glacier* (OR), *Hutchinson News* (KS), *Laramie Republican* (WY), *Leavenworth Echo* (WA), *Manhattan Daily Nationalist* (Manhattan, KS), *Medford Mail Tribune* (OR), *Morning Register* (Eugene, OR), *Natrona County Tribune* (WY), *Seattle Statesman*, *The Sun* (Vancouver), *Topeka Daily Capital*, *Topeka Daily State Journal*, and the *Wichita Beacon*.

The details of the itinerary that Inez Milholland, who was accompanied by her sister, Vida, followed on the 1916 National Woman's Party Western campaign were reconstructed from multiple sources, including the National Woman's Party Records, letters from Inez Milholland to her husband, reports and letters sent to Alice Paul from various local NWP members, *The Suffragist* magazine, local newspapers, and *Inez: The Life and Times of Inez Milholland* by Linda J. Lumsden. The timeline of suffrage in the U.S. contains the events we felt were essential to describe the long history of suffrage rights in America, but owing to space we had to leave out some important events related to suffrage, women's rights, and civil rights in general. A longer version of this timeline can also be found on the *Standing Together* project website.

As the artist notes in "Forward Together," the dominant story of the long struggle for enfranchisement of women in the U.S. has largely centered on white Americans. Though *Standing Together* looks at the movement for women's suffrage through the lens of one white woman, the critical role that Black women played in securing the right to vote cannot be overlooked. The achievement of women's enfranchisement was tainted by racism, and it is important that Black organizers such as Mary Church Terrell, Ida B. Wells-Barnett, and Frances Ellen Watkins Harper are written back into history. We recognize that self-identification by Black Americans is complex, nuanced, and has shifted over time. With that in mind, we have used the term "Black" in the essays to reflect the current prevalence of this usage among Black citizens of the U.S. We have opted to use "African American" in the timeline of suffrage, however, rather than the more historically accurate "Negro" (it being a term used in legal statutes), since "Negro" was a term thrust upon the Black population by whites in colonial and post-colonial America and was one of many tools used to perpetuate white supremacy.

The issues of historical inaccuracy and self-identification extend as well to the indigenous peoples of North America, whose histories have also been distorted and obscured by the colonialist narratives that have dominated the telling of U.S. history. The contributions of indigenous organizers have also been largely ignored in the stories of the suffrage movement. When referring to people descended from the indigenous populations of the Americas, we have used the term "indigenous Americans" in essay texts to reflect a current preference, though not necessarily the consensus, since this community of citizens is not monolithic. In the itinerary and the timeline we have used "Native American" because laws and amendments passed related to suffrage employ this term; "indigenous American" would have been anachronistic in these texts.

On the Photographs

Standing Together is a work of art that reflects history but is not a documentary. There are many challenges in piecing together a photo narrative based on historical events more than one hundred years after the events took place. Cities and towns change, historic buildings are torn down, and other buildings are renovated or fall into such disrepair that they barely resemble the original structures. Taking all of this into account, a few of the buildings in the images are meant to depict locations that no longer exist.

All of the photographs are archival pigment prints, except *A Gift of Flowers* (2019), which is a lumen print.

Acknowledgments

First and foremost, I thank all of the generations of women that paved the way for us. And those that continue to lead us forward.

I would like to acknowledge all of the people who selflessly contributed to *Standing Together* during the four years it took to bring this project to life.

To my immediate family—Mike, Nate, and Kandie Sue—thank you for always believing in me and supporting whatever I do, including this project. And to my extended and chosen family, including my parents, stepdads and stepmoms, in-laws, sisters, and friends: you all taught me (and still do) that I could be and do whatever I wanted regardless of my gender.

My deepest gratitude goes to all of the fabulous women and men who stood in for Inez, Vida, Eugen, their fellow suffragists, and the other roles represented in this project: Jane Fulton Alt, Dana Altman, Mike Bales, Chad Berry, Ella Berry, Jessica Berry, Lisa Burns, Kim Coats, Laura Coats, Gwendolyn Courtney, Megan Doherty, Bridget Fontenot, Dennis Furr, Janice Goldberg, Amy Kellenberger, Barb Knoff, David Langlinais, Juliette Langlinais, Mel McDonald, Prenity Miller, Tarian Miller, María José Herrera Ortega, Connie Paige, Bob Palka, Jackie Rockwell, Nelda Reid, Tamara Bridges Rothschild, Isabella Serrano, Brenda Talavara, Ann Vorlicky, Dennis Walker, Marsha Walker, Matthew Walker, and Alexis Zaccarello.

Travel companions made the location trips special: thank you Nate Bales, Lois Lankford, and Tamara Bridges Rothschild for the memories.

I extend my heartfelt appreciation to all who offered feedback and insight while the project was coming together: Ellen Alexandrakis, Linda Alterwitz, Donny Bajohr, Alexa Becker, Makeda Best, Mary Bisbee-Beek, William Bolling, David Bram, Frish Brandt, Andrew Burgess, Kathleen Burke, Jeff Campagna, David Chickey, Robert P.J. Cooney, Jr., Alyssa Coppelman, Arnika Dawkins, Dornith Doherty, James Estrin, Andrew Fedynak, Burt Finger, Missy Finger, Roy Flukinger, Rich Frishman, Susan Kae Grant, Kris Graves, Luisa Goldstein, Shweta Gulati, Karen Haas, Julie Hau, Ann Jastrab, Samantha Johnston, Tiffany Jones, Geoffrey Koslov, Taia Kwinter, Anjuli Lebowitz, Molly Murphy MacGregor, Sally Mann, Douglas McCulloh, Sean McGlaughlin, Alison Nordstrom, Julia J. Norrell, Lori Osborne, Marcy Palmer, W. Brian Piper, Mary Quinn, Tamara Reynolds, Molly Roberts, John Rohrbach, Jennifer Pritheeva Samuel, Rebecca Schlossberg, Paloma Shutes, J. Sybylla Smith, Elsa Smithgall, Aline Smithson,

Gordon Stettinius, Lisa Sutcliffe, Mary Virginia Swanson, Paula Tognarelli, and Martha Wheelock.

A special thanks goes to Elizabeth Avedon and Bonnie Briant, who laid the design foundation in order for the project to find a home with a publisher. And, thanks to my amazing literary agent Joan Brookbank, what a home it found. My greatest gratitude goes to Amy Wilkins and Robin Brunelle at MW Editions for diving into the project so wholeheartedly and quickly.

Thank you to the following locations, museums, and organizations: Amtrak, American Association of University Women, Aldredge House, Belmont-Paul Woman's Equality National Monument, Blackstone Hotel, California Automobile Museum, California State Railroad Museum, Cheyenne Depot Museum, The Historic Plains Hotel, Indiana Historical Society, New York Grand Central Terminal, League of Women Voters, Majestic Theatre, Museum of the American Railroad, The Palace Hotel, National Women's History Project, Oregon Historical Society, Oregon Rail Heritage Center, Stevens Building, Tennessee Valley Railroad Museum, Union Pacific Railroad Company, WildWestWomen.org, and The Yellowstone Restaurant.

My appreciation goes to Linda J. Lumsden for offering her historical expertise on the suffrage movement, specifically the National Woman's Party and Inez Milholland, and for adding her voice to the project in the form of a wonderful introduction to this book.

I also must thank Tony Rios for his retouching skills, Deborah at Iron Age Studios for working her magic on "The Star of Hope," Lois Lankford for sewing the "Votes for Women" sashes, Mel McDonald for letting us decorate his 1915 Packard for an auto parade, and Jill Donaldson for lending me her father's antique doctor's bag.

Luisa Goldstein is the most amazing co-worker, researcher, and all-around miracle worker ever. I tremendously appreciate her time and effort; this project would never have been finished without her.

Thank you to the historians, historical societies, librarians, museum collections, organizations, researchers, research and university libraries, and many others who helped me understand the scope of the suffrage movement and how Inez and the National Woman's Party figured into it.

To the phenomenal people at PDNB Gallery, Dallas, and Arnika Dawkins Photographic Fine Art, Atlanta, who go out of their way to help my work connect to audiences through exhibitions, art fairs, and online sources: I truly value our relationships and look forward to many more amazing years of collaboration.

Last but certainly not least, thank you to Carola and John Herrin, Charles Dee Mitchell, and Julia J. Norrell for being the first collectors to believe in *Standing Together*.

Captions
Front cover: Jeanine Michna-Bales, *Ready for Battle* (detail), 2019; front endpapers: from *The Suffragist* 4, no. 41 (October 7, 1916); frontispiece: Jeanine Michna-Bales, *Standing Together* (detail), Grant Park, Chicago, Illinois, 2018; p. 4: Jeanine Michna-Bales, *Sierra Nevadas* (detail), California, 2018; p. 6: Suffrage banner, ca. 1911; p. 14: Inez Milholland wearing "The Star of Hope" for the 1911 suffrage parade in New York City; pp. 26–27: Jeanine Michna-Bales, *Something Blue* (detail), Lake Michigan, Chicago, Illinois, 2018; pp. 44–45: Jeanine Michna-Bales, *Snow Fall* (detail), Wyoming, 2019; pp. 56–57: Jeanine Michna-Bales, *Snake River* (detail), near Twin Falls, Idaho, 2019; pp. 78–79: Jeanine Michna-Bales, *Mountain Pass in Fog* (detail), Oregon, 2019; pp. 102–3: Jeanine Michna-Bales, *Blue Gem* (detail), Washington, 2019; pp. 118–19: Jeanine Michna-Bales, *Amber Waves of Grain* (detail), Montana, 2019; pp. 144–45: Jeanine Michna-Bales, *Nightfall* (detail), Utah, 2018; pp. 156–57: Jeanine Michna-Bales, *Moonrise*

(detail), Virginia City, Nevada, 2018; pp. 176–77: Jeanine Michna-Bales, *Sunset* (detail), California, 2019; pp. 196–97: Jeanine Michna-Bales, *Dusting of Snow* (detail), Montana, 2019; p. 198: A handwritten and edited rough draft of "Appeal to the Women Voters of the West," ca. October 1916; back endpapers: from *The Suffragist* 4, no. 42 (October 14, 1916); back cover: Jeanine Michna-Bales, *Leaving Helena* (detail), Montana, 2019

Image Credits
Courtesy Newspaper and Current Periodical Division, Library of Congress: front endpapers, back endpapers, 32, 42, 52, 53 left, 90, 166, 193; courtesy National Woman's Party Collection at the Belmont-Paul Woman's Equality National Monument: 6; courtesy George Grantham Bain Collection, Prints and Photographs Division, Library of Congress: 9; courtesy Papers of Inez Milholland, Speeches and Correspondence, 1906–1916, Speeches, Fragments, n.d., MC 308, folder 30. Schlesinger Library, Radcliffe Institute, Harvard University: 10, 198, 201; courtesy National Woman's Party Records, Groups I and II respectively, Manuscript Division, Library of Congress: pp. 12, 21; photo by Ruldolf Eickemeyer, Jr., collection of John Tepper Marlin, courtesy of National Woman's Party Records, Manuscript Division, Library of Congress: 14; courtesy Woman Suffrage Media Project, Robert P.J. Cooney, Jr.: 17, 18 left, 22; courtesy National Museum of American History and Culture, Smithsonian Institution: 18 right; object courtesy William H. Smith Memorial Library, Indiana Historical Society: 30; first edition of *Meditations on Votes for Women* by Samuel McChord Crothers, Houghton Mifflin Co, 1914, courtesy Suffrage Collection at The Historic Plains Hotel, Astride A. Starship: 47; photographic portrait of Vida Milholland by Ira L. Hill Studio, New York, NY, ca. 1916, courtesy National Woman's Party Records, Group I, Manuscript Division, Library of Congress: 77 left; photographic portrait of Inez Milholland by David Edmonston, Washington, D.C., 1913, courtesy National Woman's Party Records, Group I, Manuscript Division, Library of Congress: 77 right; courtesy Oregon Historical Society Research Library: 97

Citations for quotations in plate section
p. 41: *The Suffragist* 4, no. 42 (October 14, 1916), p. 7.
p. 46: *Casper Daily Tribune* (WY), October 18, 1916, p. 1.
p. 58: Inez Milholland to Eugen Boissevain, October 8, 1916. Papers of Inez Milholland, Personal Correspondence, October 8–20, 1916. MC 308, folder 5. Schlesinger Library, Radcliffe Institute, Harvard University. All subsequent quotations from Milholland's letters to Boissevain are located in this archive.
p. 80: *Oregon Daily Journal* (Portland), October 11, 1916, p. 4.
p. 100: *The Suffragist* 3, no. 40 (October 2, 1915), p. 5.
p. 117: *Spokesman-Review* (Spokane), October 14, 1916, p. 1.
p. 133: *The Suffragist* 4, no. 42 (October 14, 1916), p. 8.
p. 194: Beulah Amidon to Doris Stevens, October 24, 1916, reel 35, National Woman's Party Records, Group I, Manuscript Division, Library of Congress; Beulah Amidon to Anne Martin, December 15, 1916, reel 36, National Woman's Party Records, Group I, Manuscript Division, Library of Congress. The quotation and source information was retrieved from Linda J. Lumsden, *Inez: The Life and Times of Inez Milholland* (Bloomington: Indiana University Press, 2004), p. 163, n90 and p. 174, n2.

Inez Milholland
Special Envoy

ren of Wyoming; Mrs. Nathaniel Thomas, wife
of Bishop Thomas of the Episcopal Church of
Wyoming; Mrs. Herman Gates, wife of State

Last Appeal from U

Carried to Women V

ONDERFUL interest aroused, great
crowds congregated and, above all,
y remarkable results in winning votes, are
rted in connection with the 12,000-mile
g which Inez Milholland Boissevain, spe-
flying envoy of the Woman's Party is mak-
through the twelve western equal suffrage
s. She is bearing to the 4,000,000 voting
en of the West the final appeal of the un-
anchised women of the thirty-six eastern
s, urging women to stand by women and
give their support to President Wilson and
ocratic candidates for Congress because of
opposition to nation-wide woman suf-
e.

yoming and Idaho have welcomed Inez
olland heartily and have received her mes-
with enthusiasm. To her appeal there has
a response far exceeding the wildest hopes
hose most interested in the success of her
ion. Many promises have been given to
against President Wilson, the roadblocker
ederal woman suffrage.

ter the meeting at Cheyenne, the first stop
he long tour, Miss Margery Ross, Wyom-
campaign manager of the Woman's Party,
graphed to national headquarters: "Mil-
nd meeting, Cheyenne, a wonderful suc-
." From Idaho, the second state reached,

voters of the West to
solidly against the pa
last four years disreg
women of the countr

Next came Mrs. Ha
heroic fighter who, h
dence in Kansas, is n
announced that she s
as a member of the
humor and her tellir
Wilson's change of h
question delighted he
of approval and rippl
from all parts of the

Among the notabl
Mrs. Francis E. Warr